Photo Retouching
with Photoshop

A Designer's Notebook

Photo Retouching
with Photoshop

GÉRARD **NIEMETZKY**

DOMINIQUE **LEGRAND**

ANTONY **LEGRAND**

ÉRIC **MAHÉ**

VINCENT **RISACHER**

FRANÇOIS **QUINIO**

THIBAUT **GRANIER**

POISSON **ROUGE**

CYRIL **BRUNEAU**

TRANSLATED BY
MARIE-LAURE **CLEC'H**

O'REILLY®

Beijing • Cambridge • Farnham • Köln • Paris • Sebastopol • Taipei • Tokyo

Photo Retouching with Photoshop: A Designer's Notebook
by Gérard Niemetzky, Dominique Legrand, Antony Legrand, Éric Mahé, Vincent Risacher, François Quinio, Thibaut Granier, Poisson Rouge, and Cyril Bruneau

Translated by Marie-Laure CLEC'H

Published by O'Reilly Media, Inc., 1005 Gravenstein Highway North, Sebastopol, CA 95472.

Translation from the French language edition of: *Retouches Photo avec Photoshop - Les cahiers des Designers 05* by Gérard Niemetzky, Dominique Legrand, Antony Legrand, Éric Mahé, Vincent Risacher, François Quinio, Thibaut Granier, Poisson Rouge, and Cyril Bruneau. © 2003 Editions Eyrolles, Paris, France.

O'Reilly books may be purchased for educational, business, or sales promotional use. Online editions are also available for most titles (*safari.oreilly.com*). For more information, contact our corporate/institutional sales department: (800) 998-9938 or corporate@oreilly.com.

Editor:	Robert Eckstein
Art Director:	Michele Wetherbee
Production Editor:	Darren Kelly
Cover Designer:	Volume Design, Inc.
Interior Designer:	Anne Kilgore
Printing History:	

December 2004: First Edition.

ISBN: 0-596-00860-0

[L]

Contents

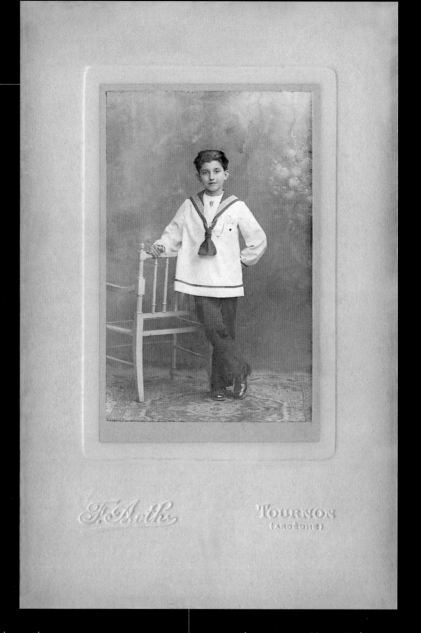

F. Aeth

TOURNON
(ARDÈCHE)

Some simple Photoshop operations can bring an old photograph back to life. Choosing high quality paper and long-lasting inks (inks that contain pigments) make it possible to preserve a family heirloom for years to come, which will make your descendants happy. All you have to do is store the corrected file on CD so you can reprint the same image whenever you want in the future. In fact, the only thing you may need to do is adapt today's mediums (CD-ROMs) to the latest technologies.

studio 01

GÉRARD **NIEMETZKY**

Hardware used
- Epson 2450 Scanner
- Epson Printer
- PowerBook G4 667 – 512 MB of RAM

Software used
- Photoshop CS

Image Restoring

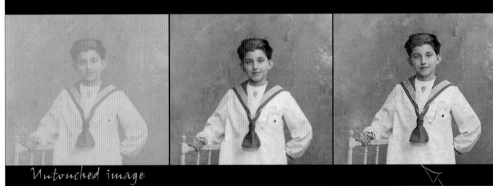

Untouched image

As I was working on a historical family album, I came across photographs that were over a hundred years old. Some were still in good condition, others required intensive restoration work.

Since the goal was to print them out and put them on a CD-ROM for each member of the family, it seemed to me that the best way to go about it was to scan them and use Photoshop to touch them up.

This magnificent, early twentieth-century portrait represents my grandfather when he was child. I knew that I had to save the original paperboard support, bearing the name of the photographer, along with the picture.

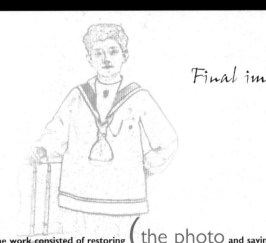

Final image

The work consisted of restoring (the photo and saving the original paperboard support.

Stage 1

Scanning the image

In order to save the image, my first idea was to scan the original photograph vertically—this is, following the vertical scrolling of the sensors of the scanner. However, since the light follows the same direction as the sensors, this made it impossible to preserve the embossed aspect of the frame which gave the photograph its specific relief effect.

On the other hand, by turning the image to a 90° angle, a shade was created during the scanning operation that resulted in a contrast. This contrast was sufficient to preserve that impression of relief.

I used a 100% ratio to scan the photograph, and a 300 dpi resolution. This was sufficient to print the photograph on a good quality ink-jet printer. As for the CD-ROM version of the image, I didn't need such a high definition version; it could be reduced later on. ▪

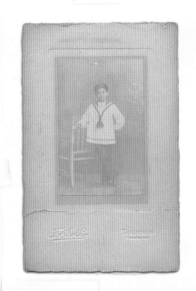

Scanner parameter settings for color management that take into account the profile of the scanner and convert the image into Adobe RGB workspace.

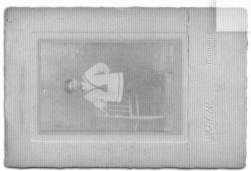

Scan carried out at a 90° angle which allows for a deeper and more accentuated background, thanks to a shade effect.

Although I was dealing with a black and white picture, I scanned it using RGB colors in order to preserve the faded, sepia shade that is so typical of old prints.

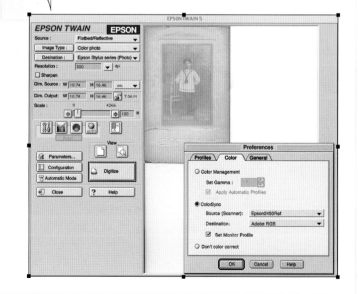

S t a g e 2

How to manage color

As a true believer of color management through ICC profiles, I used a profile that was specific to my scanner in order to acquire this image. I opened it in a Photoshop "photographic" space—in this case, the Adobe RGB (1998) space. For this particular monochromatic image, the work that was done on levels shown below was done in the Lab color space, on layer L (luminosity). This made it possible to preserve the delicate shades of the photograph. Once the image was scanned, I immediately switched from the RGB mode to Lab colors.

Before I start, I always set the values of the image back where they belong using the Image ➤ Adjustments ➤ Levels command.

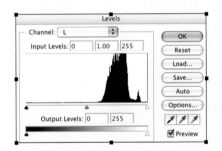

Adjusting the entry levels of the white and black points in order to rebalance the values of the image.

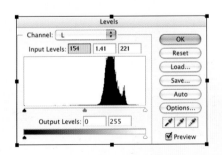

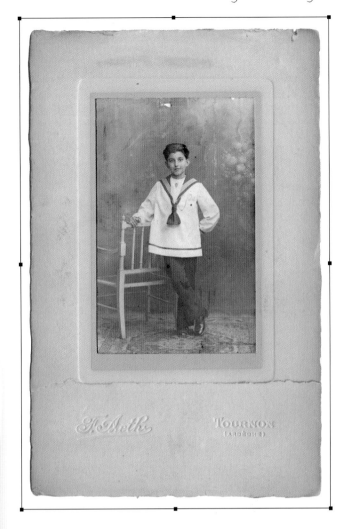

To make sure that I can come back to these adjustments later on, I use a "Levels" Adjustment Layer.

As with real photographic prints, you should never decide what should be retouched on an image until you correct the exposure. Thanks to this adjustment, all the main values of the image are perfectly placed: white point, black point, and contrast. Now I can decide which corrections I need to carry out on this image. ▪

Stage 3

What needed touching up on this picture?

This was a critical phase. The time had come to decide exactly what I wanted to do with the picture: more specifically, the order in which I was going to proceed and the tools I was going to use.

This phase gave me time to reflect on the steps I needed to perform. I wanted to keep this process both simple and logical. That way, touching up was much easier and I had time to concentrate on flaws.

I typically avoid making localized corrections on an image. Global corrections, in terms of chroma, are often more effective. However, in this particular case, I had to first work on the photograph itself, since it had lost most of its density, details, and contrast. Next, I had to work on the frame, which had kept its original color. So I started by selecting the image in order to improve it, then I reversed the selection in order to touch up the frame.

Remove flaws but keep some marks that show the ageing of the paperboard.

Touch up the photograph, keep surface in the background, improve sharpness.

Get rid of black edge.

Correct the edge.

Get rid of crack while preserving relief.

For this specific type of restoration work, I used the following steps:

- Select the photo
- Correct the values
- Increase the sharpness
- Clean and touch up the photograph first, then its paperboard frame
- Repair the edge of the photograph and the frame. ∎

Correct the edge all around the frame.

Stage 4

Selecting and correcting the portrait

Since the part I need to edit here is rectangular, I positioned the Rectangular Marquee Selection along the four sides of the picture before making a precise selection of the entire portrait.

Next, I created a Curves Adjustment Layer in order to modify it. I did this using Layer→New Adjustment Layer→Curves. On this figure, you can see the shape of the curve I used, on layer L of Lab space.

Finally, by reversing the selection (Select →Inverse), I could work on the paperboard frame. I did not want to sharpen the frame because this would have emphasized the details of the paper, thus giving it an artificial feel. I did not want to add more grain to the paperboard either, since it looked quite nice once scanned. It was only after I had corrected the values of the *image* (using the Curves effect) and then sharpened it that I could actually clean it. Touching up the image before applying a sharpening filter can ruin what has been done so far, since it magnifies all the flaws and dust. ∎

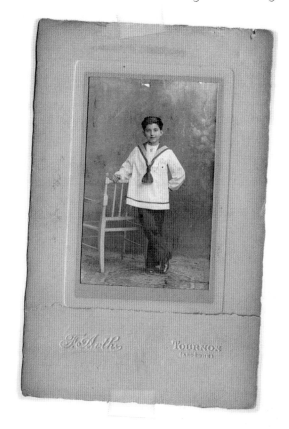

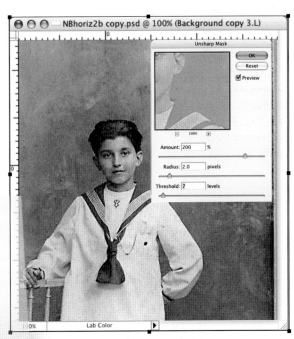

The Lab color space is my favorite tool for this kind of work. It allows for the correction of the values and contrast of the image, on layer L, without altering colors. It is also on this layer L that I apply my sharpening filter in order to bring more clarity to the portrait.

Stage 5

Touching up the photograph and the frame

I switched back to Adobe RGB color space before I started touching up the picture (Image→Mode→RGB Colors). At the very end, the image was saved using this color space. (In fact, it was printed in RGB on my ink-jet printer and RGB was used again when I saved it on my CD.)

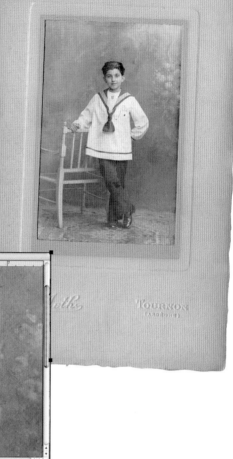

The Clone Stamp was the best tool for this photograph, and I used it to touch up the dust and scratches.

First, I Alt+Clicked to select the source that I was going to clone from.

By selecting various brushes with degrees of sharpness, I could correct these flaws with precision.

This "cloning" made it possible to erase the tear of the frame and the flaws of the photograph. ■

Selecting the zone that needs to be duplicated.

Applying the chosen zone over the part that needs to be touched up.

Stage 6

Touching up the edges of the photograph and the frame

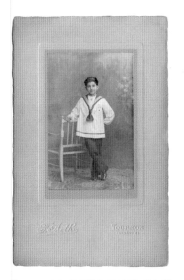

I used the same tool (Clone Stamp) to create an artificial edge all around the time-worn paperboard and to touch up the tear of the frame.

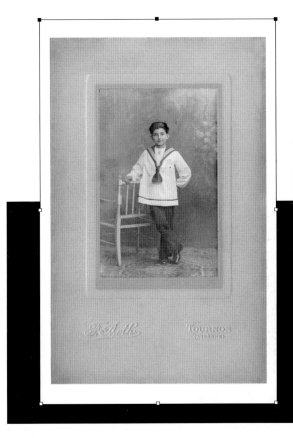

Choosing the size of the brush—as well as the degree of sharpness that the brush uses—along the edge of the area that is cloned makes it possible to adapt and correct different sized flaws. It also allows for both precise cloning of a specific part of the image (sharp clone) or the correction of a flaw (hazy clone).

I kept some of the darker areas to give the whole thing an older look. Of course, this is a matter of taste. It would have been possible to clean the paperboard completely. ∎

Since the image that was intended to be viewed on screen only, I re-sampled the image at 72 dpi and saved it as a JPEG in order to record on CD-ROM. Note that I had previously converted it to the RGB color space, which is required for multimedia use.

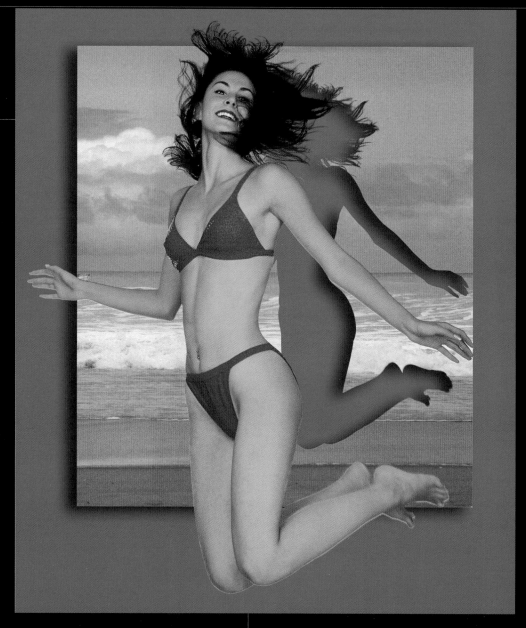

Before the arrival of digital technology, photo retouching demanded true craftsmanship. The retoucher worked on the image after the photographer and before the photoengraver. A great retoucher required both the qualities of an illustrator and the dexterity of an aerographer at handling the brush. He or she also had to have an acute sense of color and an eye for light. Thanks to digital tools, each user has now become a photographic retoucher in their own right—a wonderful thing. However, beware of any work that has been rushed and poorly done . . .

PS: this workshop is a technical exercise with no artistic ambition whatsoever.

studio 02

DOMINIQUE **LEGRAND**
ANTONY **LEGRAND**

Digital Surgery

Hardware used

- Macintosh G4 – 1 GB RAM + Macintosh iBook Combo 384 MB RAM
- Calibration and screen profile: Monitor Expert Calibrator from Alwan Color Expertise
- Wacom graphic tablet

Software used

- Photoshop CS

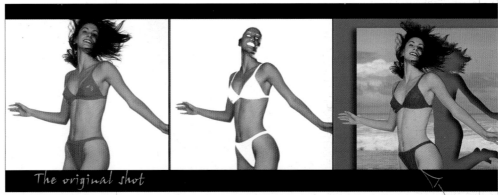

The original shot

This workshop was meant to demonstrate how Photoshop works. It was used at the Adobe booth during the 2002 Apple Exhibition. It now serves as an exercise during a training course on professional retouching for anyone who wants to use this software more efficiently and wants to understand it better.

We asked photographers Jean-Louis Scotto and Eric Ouakine, who created and run the Marseille-based Eloroann School for Top Models, if they would mind helping us with this project. During photography sessions, they would assist by making mistakes on purpose so that we could work on them later and retouch them. The picture we selected for this exercise was that of Prescilia. It required significant corrections: framing, distortion, lighting . . . it's a good thing this is a fictional photograph, as a professional photographer would never get away with such grave errors!

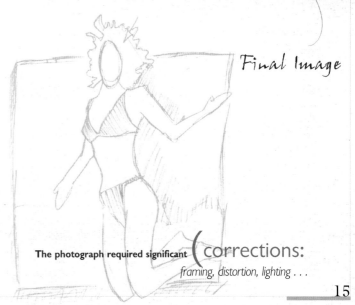

Final Image

The photograph required significant *(corrections:*
framing, distortion, lighting . . .

Stage 1

Profile Shot . . .

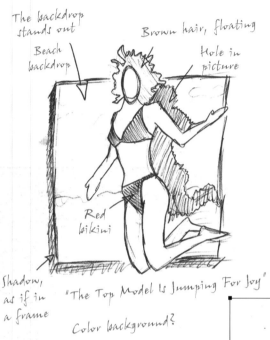

The backdrop stands out

Brown hair, floating

Beach backdrop

Hole in picture

Red bikini

Shadow, as if in a frame

"The Top Model Is Jumping For Joy"

Color background?

The idea behind this image was to show Prescilia projecting herself into reality, as if jumping out of a picture that was on a wall. (Of course, her image would remain on the wall!) Note that our objective is to focus on Prescilia and on any touching up that had to be done, not on creating the photomontage itself.

Calibration

Before I start retouching any picture, I always check the calibration of my monitor and use my colorimeter so that the colors that show on the screen correspond to the numeric data of the file. This way, I can check the veracity of the colors. It is simply unthinkable to work on an inaccurate screen.

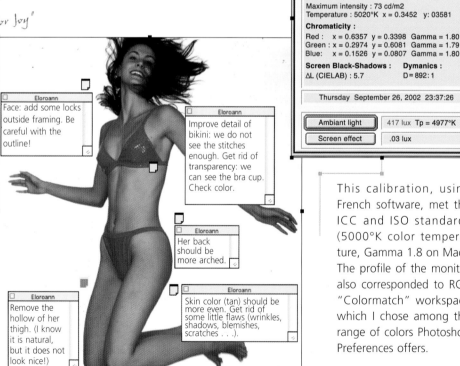

We asked Jean-Louis and Eric to play the part of tyrannical customers and to make their comments directly in Photoshop in the form of small annotations.

Eloroann
Face: add some locks outside framing. Be careful with the outline!

Eloroann
Improve detail of bikini: we do not see the stitches enough. Get rid of transparency: we can see the bra cup. Check color.

Eloroann
Her back should be more arched.

Eloroann
Remove the hollow of her thigh. (I know it is natural, but it does not look nice!)

Eloroann
Skin color (tan) should be more even. Get rid of some little flaws (wrinkles, shadows, blemishes, scratches . . .).

This calibration, using French software, met the ICC and ISO standards (5000°K color temperature, Gamma 1.8 on Mac). The profile of the monitor also corresponded to RGB "Colormatch" workspace which I chose among the range of colors Photoshop Preferences offers.

Color preferences

RGB phosphors = CMY inks: the Red layer contains the densities found in the Cyan ink, Green = Magenta, Blue = Yellow. The three RGB layers show the CMY films. Black is the only color that has an independent action. As a consequence, a correction of Magenta will be carried out on the Green layer.

I worked on this image as an RGB file. However, I could simulate, on screen, the colors that I would get using the CMYK space. To do this, select the CMYK "profile" inside the Color Settings (CMYK workspace) at Edit→Color Settings . . .

CMYK allows me to produce a customized quadric for the printer. Hopefully, my client would at some point provide me with the profile of the offset press that would be used to print on a defined paper. However, since I did not have that information at the time, I picked the Euroscale coated V2 standard.

I could then touch up the image in either RGB or Lab modes, in order to work in a vast colorimetric space and benefit from all the functions and filters Photoshop can offer. Later on, the conversion from RGB mode toward CMYK separation will be nothing more than a mere formality at the end of the chain—for example in the RIP of the CTP. ▦

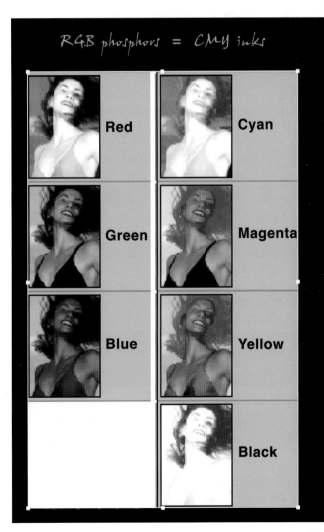

RGB phosphors = CMY inks

S t a g e 2

Color Insurance

When I save my photos in Photoshop, the profile of my workspace (here, Colormatch) is attached automatically, so that the person who receives it knows the *origin*—the source, if you will—of the colors I have used. If the file is opened under any other working conditions, the numeric data will be converted so as to preserve the true colors of the original file (and not the reverse, as one might think).

On the calibrated screen, the image that I see seems like an ekta (shorthand for Ektachrome film) on a 5000K luminous table. By providing an RGB image along with its source profile, I present the recipient with a "digital ekta". He or she thus gets the same insurance as the one offered with a traditional ekta.

When I opened the original file in RGB, a message appeared: the image did not contain the profile indicating the source of the colors—for example, the photograph lighting conditions (color temperature). This is often the case with files that come from either a digital camera or a scanner.

In the absence of such information, I gave the image my own workspace settings and adjusted the colors to my liking. Where were the "true colors"? Well, be careful. If I wanted to stay true to the red color of the bikini, I would need either a sample of it or its Lab values. I might even have to observe its fabric under a 5000K light with a standardized intensity. Then, on my calibrated screen, I could reproduce the exact color of the bikini and check if I could print it in CMYK in the same saturation.

In the meantime, I got the image on my screen. Thanks to the File Info, I checked to see if the resolution was coherent with regard to the final printing dimensions. ■

File Name	: Prescilia.tif
Created	: 23/09/02 11:52:11
Modified	: 23/09/02 11:52:13
Kind	: TIFF
Width	: 1880
Length	: 2126
Mode	: RGB
Resolution	: 300.000000
Size	: 11.5M
Bits/pixel	: 8
Resolution X	: 300.0
Resolution Y	: 300.0
Units	: inches
Software	: Adobe Photoshop CS
Date & Time	: 2002:09:23 11:52:11
Color Space EXIF	: not calibrated
Dimension X pixels	: 1880
Dimension Y pixels	: 2126

Embedded Profile Mismatch

The document's embedded color profile does not match the current RGB working space.

How do you want to proceed?
- ○ Don't Color Manage This Document
- ● Working RGB: ColorMatch R...
- ○ Assign Profile: Adobe RGB (1998)

☐ and convert the document to the RGB work space

Cancel OK

S t a g e 3

Light filtering

Eloroann
Face: add some locks outside framing. Be careful with the outline!

As with photomontages, whenever you retouch a picture, the outline remains the most critical operation because the realism of the result depends on it. Hair is the most difficult. Fortunately, in this case, the photograph was taken in a studio on a cyclo-white backdrop (thanks, photographers!).

Whatever tool is used to preserve the outline, whether it's automatic or not, the principle remains the same: exploit a difference in color density between the areas that have to be eliminated and those that will be kept. The photographic method that was used well before digital technology existed consisted of creating a "halftone mask" (sometimes called a "fuzzy mask"). This was done by using different shades of gray, thanks to either an alpha layer or to a layer mask that was allotted to an overlay. This mask represents a memorized selection which acts like a "light filter": every action is proportioned according to the transparency of the mask. ■

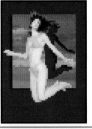

Red

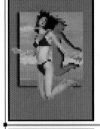

Green

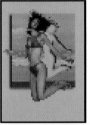

Blue

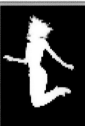

Alpha 2

Difficulties arise when the zones that need to be differentiated become indistinct, such as the case of blond hair on a corn field backdrop. Any automatic tool then becomes totally ineffective.

Alpha Layer

Layer Mask

Outline

In our case, it was more difficult to outline hair on her face than to outline hair against a light backdrop.

Fuzzy Mask

Stage 4

Splitting hair

Photoshop offers automated outline functions (e.g., the Background Eraser tool or the Extract function) which obey the same principles as the masks I described in Stage 3. These tools are quite efficient if the documents you are working on lend themselves to such operations. However, the user must also have enough knowledge to master the tolerance parameters.

When it comes to outlining hair, I prefer to use the halftone mask method. I agree that it takes more time, but it is much safer (i.e., more controllable).

To begin, I chose the most contrasted RGB layer between the hair and the zones that needed to be eliminated (backdrop and face). In this case, it was the Red layer (Cyan ink).

The next step consisted of duplicating this layer (creating an alpha layer mask) and increasing the contrast to obtain black hair against a white backdrop. However, it was also important to maintain the different shades of gray so as to ensure the transparency of the hair

You can use the Curves function to adjust the contrast of the mask. You can also use the Burn and Dodge tools for local finalization (lighter in the light tones and darker in the dark tones).

Outlining with the Extract function

Result obtained against a color backdrop

The difficulty lies in the *(adequate adjustment of mask transparency.*

Indeed, flaws stand out more against a dark backdrop: "cobweb" effects appear. Here is a trick that may help: apply an Inner Shadow layer style to the layer containing the hair. Next, make the proper adjustments individually.

Before: cobwebs effect

After having used the inner shadow

To add hair outside of the framing, all you have to do is Cut and Paste the locks. ■

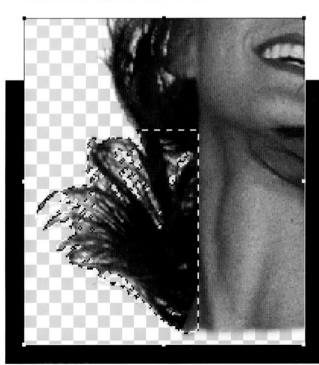

S t a g e 5

Surgery . . .

Eloroann

Her back should
be more arched.

Here, it was necessary to act in an audacious yet smart manner: using my mouse, I cut Prescilia in half from the waist down to her feet. I manually rotated the lower half as a transformation, then I repositioned the image based on the hollow of her waist.

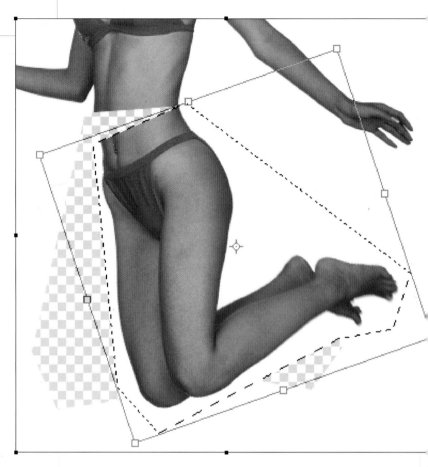

Before I proceeded with this surgical experiment and did a "skin graft" to fill in her opened stomach, I finished the outline of the body in this new position.

Vector (**paths worked well**
to obtain long, flexible curves.

Vector paths worked well with this subject as they allowed me to use long, flexible curves. However, in spite of the elegance of Prescilia's forms, certain positions had produced unsightly lines. I took advantage of this phase to modify the hollow at the top of her thigh, gave a rounder shape to her knees, and brought a finishing touch to the new curve between her belly and the small of her back.

I transformed the vector path selection into a bitmap, then erased anything that came over the outline. Using the Clone Stamp tool, I patched up the internal surface by dabbing layers of skin color. On her belly, where the rotation was, I actually copied pixels of skin. Everything should have gone well if the reference area I chose had been judiciously selected. But, I was quickly confronted with difficulties and ended up with intolerable blemishes. . . .

Luckily, Photoshop offers the Healing Brush tool, which actually resembles the Clone Stamp tool a little.

Stage 5

The ("healing brush" tool is ideal for *correcting spots and blemishes, dust, scratches, lines . . .*

In fact, this tool copies the texture only, whereas the color is recalculated according to both the pixels of origin and the environment being healed. It is the ideal tool to correct blemishes, dust, scratches and lines. Its "little brother," the Patch tool, acts the same way, but only on the surface. All that has to be done is move a selection.

At this point, I had to select some skin area to recopy it somewhere else. At first, I was faced with the same blemishes as before. However, when I released the button of the mouse, the new pixels mixed in with the original pixels and took the same color. Differences faded away even when the color of the skin was either lighter or darker.

However, there remained a problem: it was not easy to recopy the shadow above the navel, place it where it should fit, and give it the right curve. To solve this, I selected the area and used the Liquify filter which makes it possible to distort an image at a given place. A grid was displayed on the screen so that I could control the regularity of the distortion. ∎

Stage 6

Let's bring in some color . . .

Eloroann
Improve detail of bikini: we do not see the stitches enough.
Get rid of transparency: we can see the bra cup. Check color.

The lack of contrast in reds is not a problem that started with digital technology. Reproducing an image that contains a lot of red was already a problem photoengravers were confronted with before (absence of matter, lack of contours, and volume).

In printed quadrichromy, the reds are predominantly obtained through Magenta and Yellow inks. Yellow is the color that is seen as the most luminous. As for Magenta, it must be dense in saturated reds (otherwise, it looks like it is orange). As a consequence, two superimposed primary colors produce reds that lack contrast. Therefore, these two primary colors are not the ones we can count on to restore volumes.

Painters, at all times, have mixed the color red with the color of leaves in sunlight to restore the green of the foliage in the shade. This is not a new recipe: it is the complementary color which is added to restore shadows. Cyan in the reds, Magenta in the greens, Yellow in the blues.

However, Cyan ink is too light to bring out contrasts sufficiently, and that is why the reds look flat. A separation table which allows the creation of a GCR black makes it possible to improve the situation. By replacing part of a complementary color (here, Cyan ink) with some Black, the GCR partly compensates for the lack of contrast.

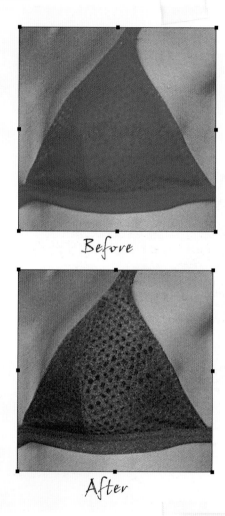

Before

After

On the RGB image, however, it is possible to anticipate the problem before the CMYK separation. All that needs to be done is to accentuate the contrast of each layer, in particular that of the Magenta and Yellow (on the Green and Blue layers).

The objective was to take (advantage **of the contrast of the**
*Red layer and introduce a share of
that same contrast in the other layers.*

The first solution consisted of accentuating the de-
tails of the Cyan ink by increasing the contrast of the
halftones on the Red layer. This was done by work-
ing on the middle of the curve. Then, I opened the
layer Mixer and selected the Green layer. I mixed in
some of the Red layer (Red cursor) to this Green
layer, which had some shades of gray in it. I contin-
ued the operation by selecting the Blue layer. The
objective was to take advantage of the contrast of
the Red layer and introduce a share of that same
contrast in the other layers.

*Careful: the color of the
bikini was modified.
As a consequence, I had to
adjust it by adding
chromatic corrections.*

*Another solution: with the color
Green selected in an output layer,
I reversed the Green and Blue layers.
The contrast is more accentuated
and I adjust the color
simultaneously.*

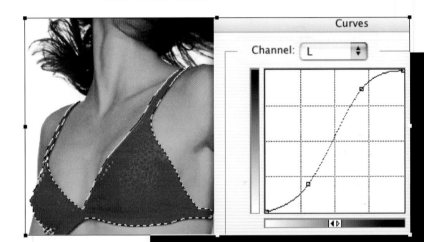

*A second method consists of
converting the RGB file
into Lab and improving the
contrast of the semitones on
the layer L.*

With this second method, one works on
brightness alone, and does not depend on the
chrominance. ∎

Stage 7

New skin

It is hard to make skin color even. One method consists of working in Lab mode. CIE Lab is a mathematical model of color representation that is based on visual perception. The color can be described in various ways: in RGB by adding light, in CMY by mixing different matters (inks, toners, etc.), or in HSB—Hue (the color itself: red, in this case), Saturation (concept of purity: sharp or dull red), and Brightness (brighter or darker red).

Eloroann
Skin color (tan) should be more even. Get rid of some little flaws (wrinkles, shadows, blemishes, scratches . . .).

Layer L (luminance) represents the contours and the matter (it is the image seen in black and white), and layers a and b describe the chrominance, that is to say, the color itself, the combination of Hue and Saturation. Therefore, having the image in Lab mode makes it possible to work on the luminance on layer L and on chrominance on the layers a and b, independently.

Creating artificial skin

I converted the RGB image into Lab mode and duplicated the overlay of Prescilia with her mask. I finished the outline so as to keep skin surface only.

OK
Cancel
Custom

◉ H:	22	°	◯ L:	70
◯ S:	47	%	◯ a:	19
◯ B:	77	%	◯ b:	26
◯ R:	196		C:	20 %
◯ G:	138		M:	43 %
◯ B:	104		Y:	49 %
#	C48A69		K:	1 %

Unlike Lab mode, these three modes depend on reproduction conditions. As a consequence, in order to communicate the exact red color of the bikini, I had to express it in Lab values. This "true color" was then converted into RGB or CMYK accordingly.

I recorded the gray values on the layers a and b of the sample color that I had requested.

Layers | Channels | Path

Lab

L

a 42% Gray

b 40% Gray

S t a g e 7

I selected the silhouette and filled the layer a with 42% of gray and layer b with 40% of gray. By visualizing a + b, I had a uniform chrominance on the totality of the skin.

Once layer L had been selected, I corrected, in black and white, the contrast, spots, and blemishes independently of the color. I adjusted the tan, the grain of the skin, etc.

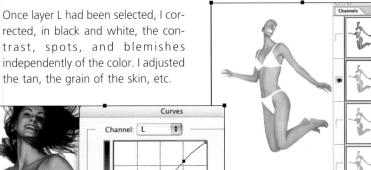

By making a and b brighter, the tan got redder and the skin yellower. The curve that I used was stored on an adjustment layer and mixed together with the preceding one.

However, Prescilia and her new skin looked like a "Barbie doll". She did not look real. It was therefore necessary to bring the opacity of the New Skin overlay to 75% in order to take 25% of the original color. Blend modes—provide the user with various pixel combinations between two overlays (natural skin and artificial skin).

Other things can be tested too: Linear Burn (white skin), Overlay (light tan) and Multiply (dark tan).

That was it: I had met the photographers' demands! However, this type of work is never quite finished . . . ■

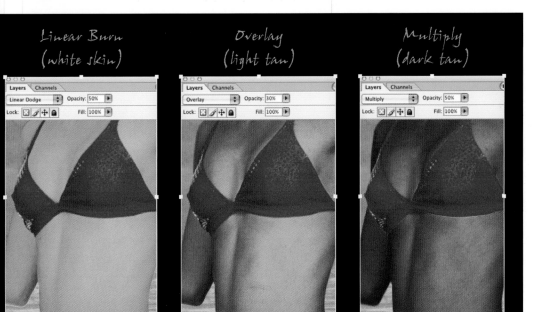

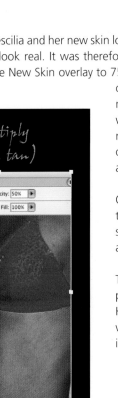

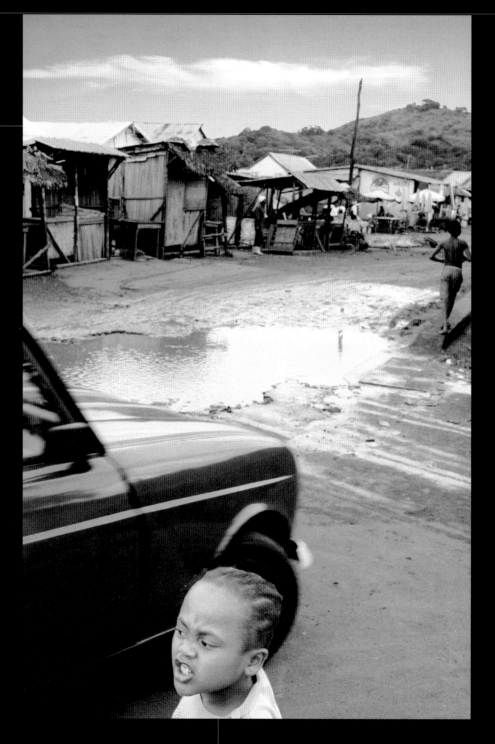

For dark or contrasted photographs, a photo retoucher can modify luminosity to his or her taste while playing with overlays and alpha layers. Another technique that can also be used is flattening the image.

ÉRIC **MAHÉ**

Hardware used
- Contax G1 with a 2/45 objective
- TMAX 400 strips
- Digital Casio QV-3500 EX
- Coolscan IV scanner to 2950 dpi

Software used
- Photoshop 6

Late Afternoon in Nosy Be

Original image

Final Image

I always thought that a good (photograph consisted of *80% framing, 10% technique and 10% chance.*

The original photography was taken in the port of Nosy Be, a small island northwest of Madagascar. This late afternoon, during the rainy season, lent itself perfectly to an active walk, at least as far as photography was concerned. With my Contax camera, loaded with a TMAX 400 film, I had everything I needed for optimal comfort and great shots. I was standing at a crossroads, and was more preoccupied with keeping my feet dry and avoiding mud puddles than thinking of what was happening around me. I suddenly caught sight of the 4L which was coming from my left and of the little girl who was trying to cross the street on the right. I "shot" almost instinctively and simply hoped that the composition would take shape spontaneously. As the contact-sheet showed later on, that was the case indeed, thanks to the presence of the young boy who moves away from behind.

29

Stage 1

Taking a first look at the shot

Unfortunately, if the composition of the photography functions as a whole, the corrections that need to be made are likely numerous. First, the main protagonist, the little girl, is lost in the uniformity of the ensemble. This fact is reinforced by the position of her face, which is located at the bottom of the image and which, as a consequence, must be sought in order to be seen. In addition, the sky is so light that it is all that we can see, and, hence, it keeps us further away from the principal subject of the picture. The little girl's face is also too close to the right wing of the car and it "blends" in too much. As for the electric wire, it does not serve any purpose. This gives us a list of the final improvements that need to be made in order to give an artistic touch to what the circumstances were kind enough to "offer" us.

Retouching work plan

The logical way to look at a photograph is from top to bottom. Therefore, I retouched it the same way. First of all, the sky needed some "filling in," so as to rebalance the entire picture. Next, I concentrated on the portion of the photograph that includes the car and houses of the village. Finally, I worked on the luminosity of the little girl's face so that it would have the place it deserved. Following this order in the management of the retouching process allowed me to gradually rebalance the composition as a whole. ■

This electric wire does not look very nice.

The sky is way too bright.

The village lacks contrast.

The car is not dark enough.

The little girl's face does not stand out enough.

Stage 2

Removing the Malagasy sky

A white sky, without the slightest cloud, is a nightmare for all photographers. Indeed, it requires delicate work in order to be artificially enhanced by hand under an enlarger. This prevents the eye from getting lost in some irrelevant part of the photograph. Moreover, it is only after the picture has been developed (and it often takes several fruitless trials), that it is possible to measure the weight of such a bland sky.

Gray levels

Photoshop allowed us to check whether the over-exposure might have burned some clouds. We can check this by pushing the gamma a little. Unfortunately, the result looked too "dirty," with a grain that diminished the quality of the image. Consequently, this entire piece of sky had to disappear and be replaced by clouds that came from somewhere else, as we shall see in the following stage.

Lasso with the Subtract option, so as not to erase bits of roofs unnecessarily. Then, using the Rectangular Marquee tool along with the Add option, I included the antenna that I wanted to remove, as well as the wires that were attached to it. A 3 pixel feather, as well as a 5 pixel smoothing, gave me the perfect selection. The Erase control of the Edit menu allowed me to make room for the new sky.

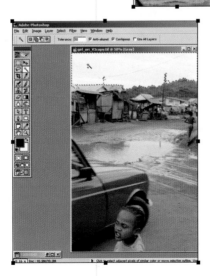

First of all, in order to remove the sky, the background had to be copied onto a new layer so that I could move it around. The next step consisted of selecting the sky. Making use of the Magic Wand seemed quite appropriate here, with a basic tolerance of 32. The result was not perfect (it never is), but Photoshop provided me with all the tools I needed to make things better. First of all, I used the

Stage 3

Clouds made in the USA

It happened that, during my last stay in Las Vegas, I had taken a beautiful shot of some stratocumulus clouds with my digital camera. The idea of mixing the two technologies was appealing to me. Indeed, it was quite a challenge to try to perfect this composition by reuniting elements that were, initially, some 9,000 miles apart.

However, I had to make some changes in order to properly integrate this piece of American sky. Because the photo-graph of the clouds was in color, it had to be converted to black and white to fit in with the initial photograph (I used the Image→ Mode→ Grayscale control). The Levels control enabled me to give the clouds a tonality that corresponded better to a Malagasy light. The only manipulation I had to do was a drag-and-drop of the cloud layer in the photograph and then invert the layout of the layer. I was almost there.

Updating the images

It happened that, during my last ⟮stay **in Las Vegas, I had** *taken a beautiful shot of some stratocumulus clouds.*

I say *almost* because the dimensions of the clouds did not quite correspond to those of the sky that needed to be re-placed. Once again, I had to select the im-age of the clouds and, in the Edit menu, use the Transform menu item. Once the two overlays were active again, the manual removal of the clouds made it possible to fit them inside the photograph. ■

Stage 4

Caution: school

It was now necessary to separate the corrections that were going to be made on the village/car unit from those concerning the little girl. As a consequence, this step consisted of select-

In regard to selecting, (**simplicity** is often *synonymous with effectiveness.*

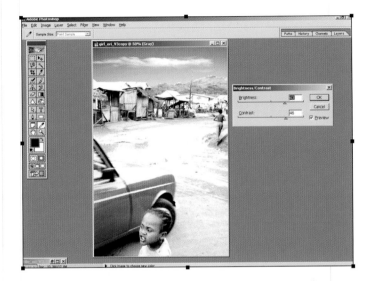

The first thing I had to do was modify the contrast and brightness of the image I had duplicated in order for the little girl's face to stand out as much as possible against the background. Then, I used the Magnetic Lasso tool with 2 pixel-width options, and a 2% edge contrast. This allows Photoshop to stick to the difference in luminosity between the edges. A 30-point frequency made it possible to obtain sufficient antialiasing to give a realistic selection to the face. I added an extra 5 pixels to the selection that I had obtained, saved it in an alpha layer that I then transferred to the main picture. I could now close the duplicated image. ■

ing her face in order to isolate it from the background of the image. Later on, I used this selection in order to remove it from the rest of the photograph. When using Photoshop, it is often easier to isolate a minimal portion of an image and remove it from a broader ensemble than the opposite. In regard to selecting, simplicity is often synonymous with effectiveness.

To do so, I created a copy of the image as it was. I had to do some "work" on it, in order to make the outline of the face easier.

Work on the copy ▷

Stage 5

A profitable operation

Let's not forget that the final objective of this work was to make the little girl's face stand out from the rest of the photograph. Therefore, in order to achieve this goal, I used the tool that has made Photoshop indispensable in the field of retouching: calculations.

The first manipulation consisted of memorizing the selection that dealt with the village in an alpha layer. The next step was to call in the Calculations control from the Image menu. I achieved my objective thanks to the selection of the right options (referring to the two alpha layers, working in the Difference mode results in the form of selection). The little girl's face really stood out from the rest of the photograph. It was magical!

Now, I had to modify the contrast and scales of the village/car unit in order to adjust them and match them with the face of the little girl. I took advantage of this process to rectify a small detail: the hubcap prevented me from enhancing her face as much as I wanted too.

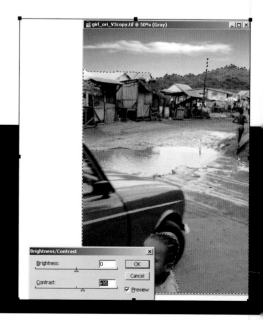

Since the selection I had made beforehand (protected it,

I erased the hubcap by dabbing it out. Safe and simple.

I also chose to lower the clouds (clouds **down just a few millimeters,**

so as to stress the higher part of the sky.

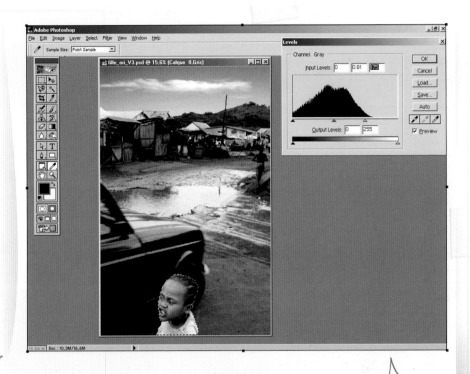

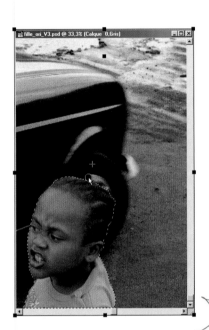

Since the selection I had made beforehand protected it, I erased the hubcap by dabbing it out. Simple and safe.

The final touch

The last thing I had to do was to call in the "Girl" selection from the alpha layer and use Levels to adjust the brightness of the face. I also chose to lower the clouds down just a few millimeters, so as to stress the higher part of the sky. Here again, it is a matter of personal choice. ■

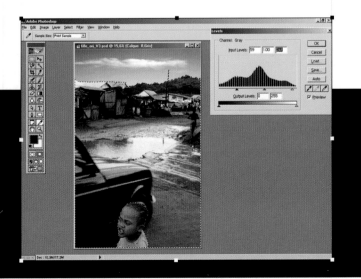

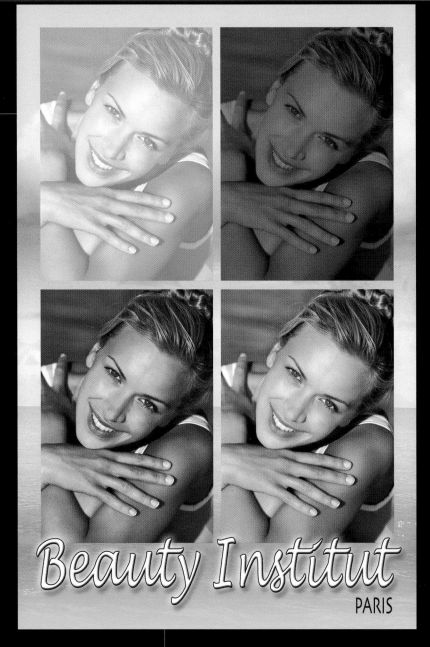

Beauty Institut

PARIS

By using colorized images, the eye feels magnetized, as if captured in a net of colors, of lights and contrasts. The client has attained its initial goal: to be looked at!

VINCENT **RISACHER**

Hardware used
- Rotary scanner Dainippon Screen SDR 1045 AI
- Macintosh G4
- 1 GB of RAM
- 100 GB hard disk

Software used
- Photoshop CS

Beauty Institut

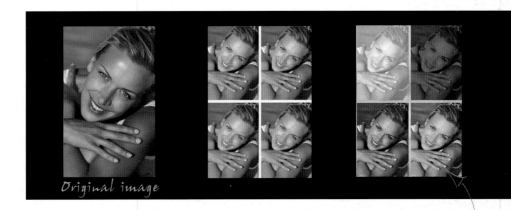

Original image

Final Image

Communication agencies often work on both exciting and surprising projects. The flyer that is presented here is a faithful replica of what can be achieved when working on the restoration and touching up of images—in this case, a person's face and a background that needs to be amalgamated.

It was essential to understand the customer's priorities from the beginning, in order to meet his demands without taking anything away from the initial idea. Now that I was in control of the keyboard, and backed up by the artistic director, I had to do my best to respect the photographic intent while proposing improvements and modifications which corroborated the agency's request.

Touching up the face, playing with various colorizations, the die was cast . . .

Touching up the face, *(* playing **with various colorizations,**
the die was cast . . .

Stage 1

Conversion

Before working on the various phases of colorization, the color picture had to be converted into different scales of gray. There were several solutions that I could use.

I started with the fastest solution: Image→Mode→Grayscale. That did not correspond at all with the dynamics of a true black and white picture!

With an approximate 10% modification for each channel, the result is, very often, quite satisfactory. In order to finish adjusting the picture, I used another adjustment layer, but this time it was Curves. Thanks to the black and white levers, I placed the extreme values of this picture at 4% and 97%.

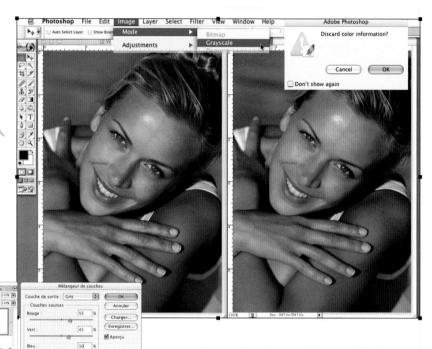

I then chose what seemed to me the most appropriate solution: use the Image→Adjustments→Channel Mixer control. However, instead of doing this directly on the picture, it is always preferable to remain as flexible as possible and therefore use an adjustment layer. Once the dialog was displayed, I checked the Monochrome box and made the necessary adjustments basing myself with Photoshop: R=55, G=45 and B=10. I always remember that pre-adjustment files are kept in the Goodies file of the Photoshop CD-ROM. I clicked on the Load button, and got to the file I needed. I loaded some files and came back to my initial adjustments.

It seemed to me that I had to slightly modify the curve in order to improve the contrast. Now that that was done, the picture was properly converted. Since I used Adjustment Layers during this conversion, it would be much easier to make corrections later on, if needed. ■

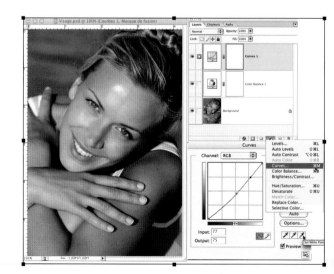

Stage 2

Surface retouching

The next stage consisted of surface retouching. A quick glance at the model's face revealed areas of the face that did not show any details. Moreover, I felt I also had to touch up some other areas of the picture.

One big plus that Photoshop provides the user with is the Healing Brush tool. Quite similar to the Clone Stamp tool, it offers many advantages and is easier to use. It should almost be named the Smart Stamp tool. By Alt-clicking on a neighboring area to set the origin of the overlay, I created the illusion of skin on the hotspot of the forehead with very little help. I then repeated the operation on one of the young woman's cheekbones. Next, I switched to the Clone Stamp tool to erase the beauty spot on her shoulder and the grains of sand along her arm. Finally, I used the Healing Brush tool again to correct any skin irregularities that I could see: the small lines under her eyes, nose, and mouth.

Untouched image

As a whole, the result corresponds to my objective, which is to preserve a sharp picture without amplifying or modifying the original grain of the photograph and skin.

All I had to do now was work on sharpness. In order to preserve the softness of the grain of the skin as best as I could, I duplicated the image onto another layer. Then, activating the Background layer, I applied the Sharpen → Sharpen More filter. All that was left to do was to create a mask on the duplicated copy, then play with the Airbrush tool. By giving it a 70% opacity and a black foreground, I could choose both the intensity and area where I wanted to apply the filter: eyes, eyebrows, a specific part of the mouth and hair. ▪

S t a g e 3

Retouching the density of the picture

In order to properly carry out my work, I merged the duplicated layer with that of the Background. Then I used the Burn and Dodge tools to retouch the picture.

These tools come with some funny parameters. Used as they are, they can only ruin the picture, because their parameters have values that are way too strong. As a consequence, the first thing the user must avoid doing is to have a result that is overly bright or, on the contrary, overly dark. That is why I did not hesitate to reduce the exposure ratio by 15% and worked on the midtones.

To begin with, I used the Dodge tool in order to unify the light around the face, nose, and roots of the hair. I also sharpened the intensity of the look by clearing up the white of her eyes. Then, thanks to the Burn tool and a rather small brush, I underlined the contour of her eyes, eyebrows, and mouth. The next step consisted of rebalancing the lights of her ear, then with a much larger brush, I gave her hair and hand the final touch by making them slightly darker. A few years ago, this type of retouching was done with a brush and a chemical called ferricyanide. It required as much expertise and delicacy as the Photoshop tools today: it is thus strongly recommended to have both fingers close to the Apple/Ctrl+Z keys! Compared with the original picture, this one has gained in contrast and punch. ∎

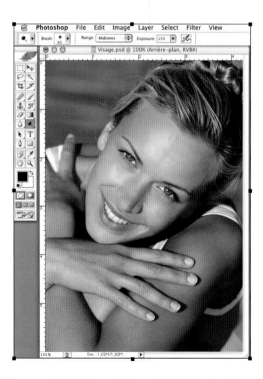

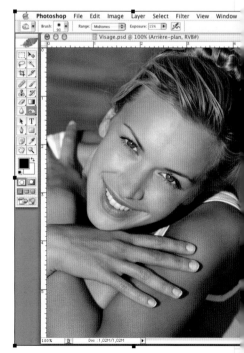

Stage 4

Last preparations before colorization

In order to prepare the various assembly phases, I opened a new document and gave it the same dimensions as the flyer. Once I had created a group of overlays in the Layers palette, I clicked on the picture of the young woman. I bound all the overlays and, with the Move tool, I moved them toward the group of layers that I had created beforehand.

Once all the layers had been incorporated into the group, I joined the adjustment layers, along with the picture of the young woman by using the Layer→ Merge Layers command. Then, I placed the points of reference which, by default, snap to the correct position. This enabled me to easily position the pictures. To obtain the four pictures I needed, I duplicated the group of initial layers three times. I simply renamed them: Top Right and Top Left, Bottom Right and Bottom Left. With the Move tool, I arranged the four images into the montage.

I now had to pick the colorization color I wanted. I chose an "orangey" shade. However, I decided to "treat" myself and skimmed through a range of different orangey shades which varied according to their Hue, Saturation, and Brightness. After having created a new document and filling it with the original orange color, I chose the Image→Adjustments→ Variations command which enabled me to go through all the different shades in no time at all. I clicked a few times here and there in order to give the shade I had selected a redder and brighter touch. I clicked OK to confirm these modifications. With the Eyedropper tool, I removed this new orangey color from the document and declared it as my foreground color. Since I did not need this document any longer, I closed it.

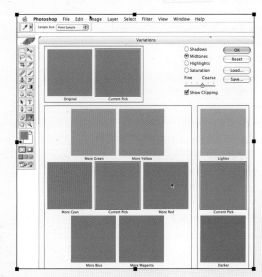

I always name and arrange my (layers carefully in the event that *someone else might have to work on them.*

Stage 5

Colorization

There are several ways of colorizing a picture with Photoshop. Different commands can be requested: Duo-tone, Color Balance, and even Variations. Here, I chose to use the Hue/Saturation command because it offers, in a single dialog window, all the parameters which define a color: hue, saturation, and brightness.

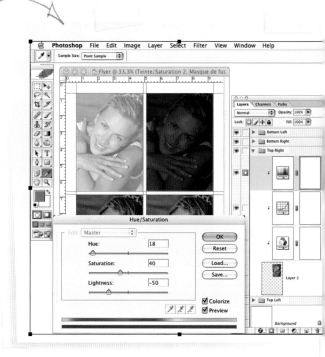

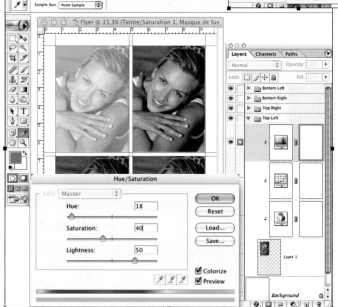

Having made sure I had renamed each overlay group, I created a Hue/Saturation adjustment layer inside the Top Left overlay group. Once the command was displayed, I validated it without touching anything and then moved it to the top of the group. I double-clicked in this layer in order to display the dialog box and checked the Colorize box.

By default, the colorization color that was suggested was that of the foreground. In the preceding stage, it was necessary to define this color as the foreground color. Hence, in order to simulate a colorization which was to resemble a print made on white paper with color ink, I inserted a +50 brightness value and confirmed by clicking OK.

(Colorization is a subtle way of making things more beautiful. *Beyond the reality of the picture, it allows for the creation of a world based on the atmosphere that derives from it.*

Stage 5

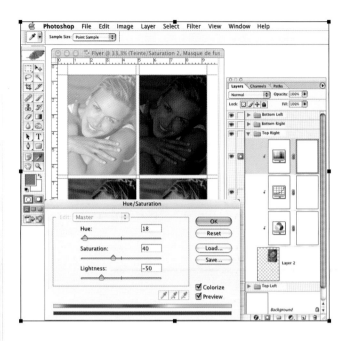

With regard to the picture situated in the Bottom Right group, I proceeded the same way, but with a 0 luminosity value. This is the most common colorization: the result resembles a print that has been made on white paper, with black and colored ink.

As for the last picture inside the Bottom Left group, I chose another means of colorization. I picked a new Solid Color Fill Layer and placed it over the other adjustment layers of that same group. To activate the colorization process, I switched from Normal blend mode to Color mode. A slight modification of opacity enabled me to obtain a uniform result in color saturation. ▄

I proceeded the same way with the Top Right layer group. I used a similar adjustment layer but with a different type of colorization, the type that simulated a print on colored paper, with black ink. In order to do that, I checked the Colorize box and inserted a –50 brightness value.

This working method allows for colorization of straight-line type documents, without having to resort to selections. In order to directly colorize the black straight line without modifying the white area, it was necessary to adjust the brightness value to + 50 and play with hue and saturation. On the other hand, in order to colorize the white zone, the brightness value had to be set to –50. In both cases, the user must check the Colorize box beforehand.

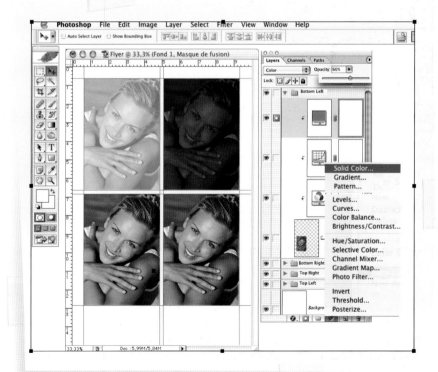

Stage 6

Chromatic retouching

All the pictures now were coherent but still required some re-fining. Each picture was the result of a Color Balance, Curves, and Hue/Saturation adjustment.

I worked on improving and standardizing both the brightness and contrast of each picture. To do so, I double-clicked on each Curves adjustment layer and modified each curve repeatedly.

Substantial (corrections **are made in order to better** *enhance the lights and contrasts of each picture.*

Visualizing the various correction phases.

Each adjustment layer came with a ma[sk] which enabled me to reduce the intens[ity] of the color (Dodge or Burn). I selected t[he] Airbrush tool to work on the correction[s I] had to make and gave it an 80% flow param[e]ter. Since this tool is flexible and sufficiently d[if]fuse, it allows for simple and quick correctio[ns] while keeping the user in a photographer-l[ike] frame of mind.

For each image, I made substantial correcti[ons] in order to improve the lighting and contrast [of] each one. Again, I revised each adjustment la[yer] mask. ∎

Stage 7

The Grand Finale

The last action to be performed consisted of placing the picture of the seaside within the montage, then typing and positioning the text. Once I had opened that picture, I slipped it inside the montage thanks to the Move tool. Once that was done, I simply laid out the copy of the seaside over the Background layer. I would come back to it a little later.

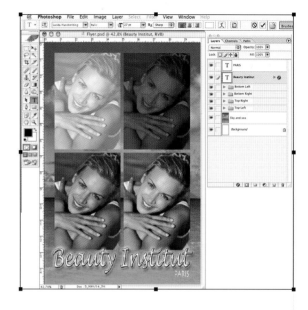

Next, I typed in the caption and positioned it. I also used the Character palette to modify spacing as well as the vertical scale. I justified the entire line. I placed this copy of the text over the last group of overlays and clicked on Layer Styles. I decided that I wanted to cumulate various effects: Drop Shadow, Outer Glow, Bevel and Emboss, and others. Now, I could concentrate on the seaside.

In order to attenuate the excessive saturation of the picture, I created a Curves Adjustment Layer and lowered the extreme value of the black point to a value roughly reaching 30%.

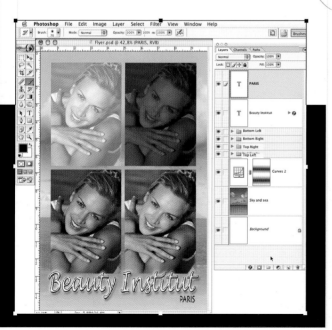

Finally, in order to modulate the whole picture, I used the Reflected Gradient tool (under Gradient Tool) with a modification of the Drawing mode (I switched from Normal to Multiply mode). That gave me the possibility of adding two or more gradations, instead of replacing them little by little. I chose to apply two gradations: one between the top and bottom pictures, the other at the base of the text so as to make it more legible. The retouching phase was now over. Since this was done thanks to overlays, the customer could add corrections as he saw fit without any difficulty. ■

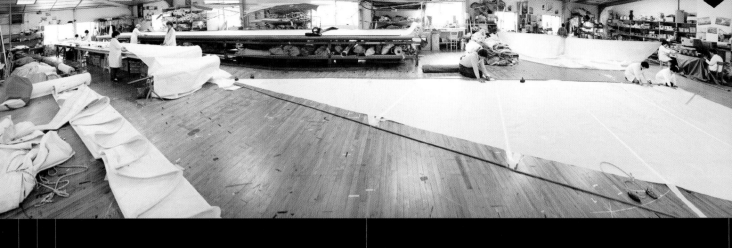

Beyond its technical interest,
panoramic vision is, for me, a space
for expression. If large format prints
attract the eye because of their size,
pan shots often encourage the observer
to scan the image. Thanks to this
workshop, I hope to give readers the
desire to use the tools I used to

studio 05

FRANÇOIS **QUINIO**

Hardware used

- Room Sinar P2 4×5 inches
- Plans films – Black and White
- Macintosh G4
- 256 MB of RAM
- 20 GB hard disk

Software used

- Photoshop 7

Sails, Perspectives, and Curves

Assembling the photos

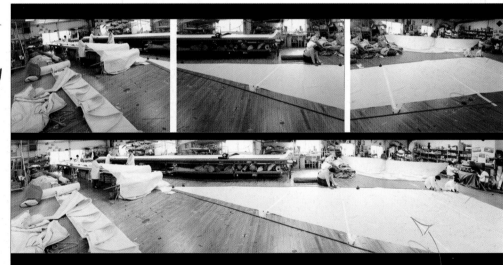

Images linked together

As an independent photographer, I was converted very early to digital technologies. Sometimes, colleagues call me and ask to carry out some digital manipulation on images they have taken.

In this particular case, I had to work on a rather imposing project: the print of a sail-making workshop. Three consecutive negatives of the workshop had to make up one single pan shot to decorate a stand during the Paris Boat Show. The final version was to be a 4 X 13 feet print! The API Studio, located in Larmor-Plage (Morbihan), France, specializes in advertising photography. Once API had taken the pictures and examined the specificity of what had to be done, they entrusted me with the responsibility of regrouping the three photographs into one single image

One (print, **made out of three negatives,**

was to constitute a pan shot for a stand during the Paris Boat Show.

Stage 1

Pre-visualization

The photographer's objective was to emphasize the horizontal plane of the floor and the movement of the fabric. The various distances between the foreground (2.6 ft.) and the far end of the workshop (65.5 ft.) forced him to resort to the rules of hyper-focalization and of Schleimpflug technique. It was thus essential to use a large format camera here.

Photographer's view

In addition to the fact that it was impossible to ask the workers to stop their activities while the photographer was shooting, two other elements hindered the process: the combination of optical aberrations due to a diving wide angle shot, and rotational movements. On one hand, a 4"x 5" view camera makes things easier from a technical point of view and allows one to take a perfect picture. On the other hand, it alters what is required to properly link up images.

This gives me the opportunity to remind the reader of some precautions that need to be taken during the linking process. Each lens has its own distortions (barrel distortion, for example), which can be measured on the edges of the optics more particularly. That is why the wider the covering (between 20% and 30% minimum), the easier it will be to link up the images.

Nodal point Rotation optical axis

View-finding axis

Overhead view

Rotation

I set up the view camera so that the nodal point of the lens was superimposed with the rotation axis of the ball-and-socket joint. If levels are perfectly regulated, the view camera ensures the faithful reproduction of shifts, rises, and falls. This makes framing possible.

First analysis: the first thing I had to do on the Polaroid controls was to check if I had plenty of overlapping. Yes, I did!

How the image is set up

Camera Rotation

Although this might look easy enough to do, it is quite technical. For the time being, the continuity of the pan shot must be put to one side a little. As planned, it is necessary to modify perspectives and to rectify some parts of the images. ■

S t a g e 2

Organizing the work

The structure of this example results from personal experiences: for each project, I am used to creating three files which correspond to the major chronological phases of my work. Here, I have named them "sources," "work," and "ultim" respectively.

Structure conditions behavior. Clear structures enable effective behavior.

Photoshop meets this concern for organization rather well. Thanks to its File Explorer it is easier to see how a project is moving ahead. The information concerning a selected file, the pre-visualization, and the tree structure are visible simultaneously.

The original negatives were traditional black and white pictures (4" X 5"). This made it possible to obtain excellent definition quality. Their digitalization in a 5132 X 4005 pixel file format was sufficient for a large format, inkjet print.

In the top left corner of the screen, it is possible to pre-define the adjustment tools. This is very useful in order to define the size of the brush, its opacity, its mode, or even the flow of the instruments that are used for retouching (History Brush, Clone Stamp, etc.).

The quick construction of a "model," in low definition (72 dpi), enabled me to pre-visualize the final image, thus giving me an idea of what had to be done to bring this work to a successful conclusion. I also used this model as a guide for the final job in high resolution. This means of preliminary research guarantees the technical, artistic and commercial success of the project. The three main retouching phases showed on the model. I named them: the setting, the sail, and the linking-up process. ■

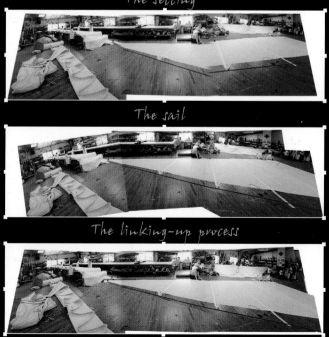

The setting

The sail

The linking-up process

Working area

In order to move and distort file perspective better, I envisioned a broader and higher working area than that. Starting with image 1a, I went to the Image → Canvas Size of the working image and modified its dimensions. I made it wider so it would fit in the three distributed images, and I made it higher to give myself a big enough margin.

S t a g e 3

Setting up the decor

For the final pan shot in high definition, I proceeded the same way as for the model: the manipulations were identical. I gathered the three source images (one per copy) in the same file.

Before going any further, I quickly checked the Levels of each image in order to evaluate their contrast and density compatibility in case I had to make any corrections. Everything was fine! The Levels were coherent.

Superimposing copies 2 and 1a makes it easier to obtain an accurate adjustment. To do so, I used the Distort option of the Transform Selection command (shortcut: keyboard Apple + T).

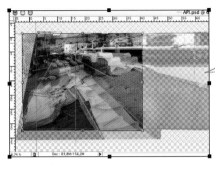

Distortion option

To link up the three elements of the pan shot, I needed to superimpose and align the photographs very precisely. I placed the source images in a Layer Set named "SOURCES." Then I created a new "Models" set. I copied the settings in that group and called it Copy 2. I put it on the same scale as the one used for the work file. Using superimposition allowed me to make the same corrections as the ones that were made on the negative that was given to the customer. The construction guides (in blue) have the same proportions as those of the model.

Perspective displacement

By holding the Apple key down, I clicked-and-slid the stylus in order to move the handles of copy 1a on the edges of the model (this can be done by using the mouse, too). The transparency of the copies facilitated that operation.

Stage 3

During this phase, I ignored the lining up of the sail. My only concern was to make the decor of the workshop logical: matching, shifts, rises, and falls. Then, thanks to a selection of the contours of the elements I wanted to bring in to the picture, all I had to do was go in the Layer menu in order to add an alpha mask.

Selecting one particular portion of the floor and giving it a progressive contour of a few pixels allows for its rotation on another layer that is added to its mask. I chose to move the small central point of the manual Transformation tool (Apple + T) toward the top right corner.

Alpha mask icon

Manual rotation

There was a faster solution for this. A simple click on the Alpha Mask icon made it possible to get the same result in one go. By doing this, the mask bound itself in black and white next to the "copy 1a."

A (Curves **adjustment layer can be added**
to the preceding copy.

Once I had put the three copies together, curves enabled me to roughly match them. I could add a Curves adjustment layer to the preceding copy if I wanted (once again, I ignored the aspect of the sail).

In order to align the floor properly, it was necessary to carry out a slight counter clockwise rotation to compensate for the displacement from the point of view of the camera. Rather than using the Clone Stamp, it is often more effective to copy an area of the image instead.

Selecting the wood floor

I saw that it was possible to visualize each copy on the palette and follow all the operations that had been carried out, step by step. I saved the whole thing under "APIdecor" so as not to overload my working file (200 MB). This also enabled me to go back to that file whenever I wanted to. ■

51

Stage 4

The sail

To draw the sail, I followed the exact same procedure as the one carried out for the decor. This time, my objective was to focus on the apparent coherence of the shape of the sail.

I placed the three copies in the same file, with the margin I had set beforehand, which renders displacement visualization easier. As in the preceding stage, the center copy was placed above and would not be moved. I would use the other two for distortion.

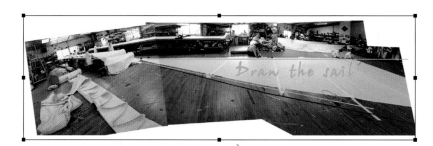

Draw the sail

Sail model ⟶

I had to pick a common element between the two negatives to line up. I chose the weight at the right of image 1a as a point of reference (this is a piece of cast-iron used in photo studios and on theatre sets). Because the copy was underneath, I could precisely click on the object I had chosen and move it. I could also match it with its clone on the other photograph (thanks to the Move tool). This operation was made easier by setting the transparency of the layer placed over this one at 50%. This spot became the center of rotation which would allow me to line up the sail.

Copy displacement

Actually, the floor helped me a great deal. Its boards served as a structure. As a consequence, I was going to take advantage of that, as best as I could, to find its original shape. The reader can see the two slats which define the edges of the sail. They guided me and helped me rebuild the ground perspective, and, as a consequence, that of the sail.

It's a piece of cake, especially for those who have worked with Photoshop 2 . . . and the first generation of Macs.

The following commands allow for the displacement of the central point to the spot that has been chosen, and for the rotation around it: select Copy, Edit ⟶ Free Transformation. Or you can click on the right button of the mouse or on Apple + T (which is much faster . . .).

Stage 4

Linking up
the sail

This copy included a negligible part of the image only: the halyard of the sail. As a precaution, I never erase the slightest portion of a photograph. I always use the mask to hide undesirable parts. To keep track of the evolution of the layers, I called in the "small camera," which is located under the History Palette and which defines a new snapshot.

The luminosity correction curves, sometimes added to the copy along with a mask, were orange and always visible in the palette. On the curve illustration, a dotted line defined the separation zone for the merge between the two images. The Curve 1b correction applied to the copy (1b center) gave the central copy a brighter shade, which was identical to that of copy 1c right, which, in our case, was considered the standard.

As a precaution, I never (erase

the slightest portion of a photograph.

If the reader observes the Layer palette, he notices that the yellow color group which contains the sail model is deactivated, whereas the distortions and masks are carried out on the original copies, in gray. The decor (in blue) was added thanks to a merge of the preceding stage.

Layer
palette

On the Decor copy, an inversion and light transparency made it possible to properly measure the connection quality of the images. During the two decor and sail phases, the central copy remained identical to the original. It was neither displaced nor distorted. I gave both files the same pan shot space. It was thus easy to superimpose them to obtain the final image. All I had to do now was to finalize this image. ■

Checking the
linking-up
process

Stage 5

Assembling the parts

We have just seen the retouching process of "sections of images" as if it were possible to cut out slices of photographs according to the depth of the field of view: the average field which corresponded to the sail, the background (named "decor,") and the foreground (which consisted of the floor and was worked on together with the decor and sail). The model was what led me to that slicing approach. However, the top right corner of the image still showed some vertical defects (negative 1c).

Palette and top right corner

Before definitively assembling the two major elements of the retouching phase (decor, blue copy and sail, purple copy), I reintegrated the source image 1c into the working file. I had two objectives during that adaptation phase: find the same framing as for the decor and rectify perspectives in order to rebalance the vertical lines. I added a new mask by following the contours of the sail on the purple copy.

I quickly checked and compared the source images and the pan shot and realized that something was gone. During the layers assembly, the cast iron weight had disappeared. Thanks to a copy of file 1b and thanks to the layer mask, it found its initial place, along the sail, on the side of the mast.

(Snapshots were taken

whenever I happened on something new, in case I had to make corrections.

Even if it was not perfect yet, I considered the image composition satisfying and saved it, along with all its copies, in psd format (APIfinal.psd). Then, I made one single copy in TIFF format (APIfinal.tif), which I was going to use for retouching. Snapshots were taken whenever I happened on something new, in case I had to make corrections. ■

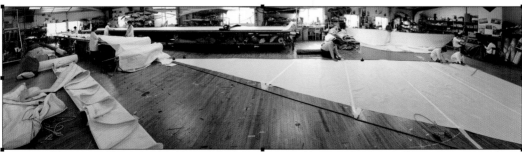

Image composition

S t a g e 6

Touching up

The touching up phase is carried out on photographic prints in the laboratory. Today, this type of intervention is no longer necessary, thanks to more advanced printing equipment. It can be done directly during the data-processing phase. Some of my colleagues proceed right from the beginning, when the image opens, in order to get rid of the dust that results from digitalization or from the original shot. For my part, I prefer to intervene at the very end of the retouching phase. This allows me to correct potential bugs that derive from the various operations that were done on the image.

The (**History Brush tool** **is extremely handy.**
When it is used together with the Dust & Scratches filter, it facilitates the correction of scratches and dust.

Dust close-up

Two types of bugs appeared in the digitized files: white spots which came from the original shot (scratches, bubbles, and dust) and dark spots (dust or fibers generally acquired at the time of digitalization). History Brush is the name of an extremely handy tool which, when used together with the Dust & Scratches filter, facilitates the correction of scratches and dust.

In the History palette menu, I chose Options and checked the Accept a nonlinear history box. Then, I went back to the Background layer, applied the Dust & Scratches filter (Filter → Noise → Dust & Scratches) and gave it enough ray value to get rid of most of the dust. I also indicated the threshold value so that the structure of the image would be preserved.

In the History palette, I clicked on the square-shaped heading. That enabled me to define the source for the form of history. Its logo was thus active on the same line as the Dust & Scratches filter. Next, I slid the cursor toward the top: the Open heading was underlined in blue.

Finally, I selected the History Brush tool and set the size.

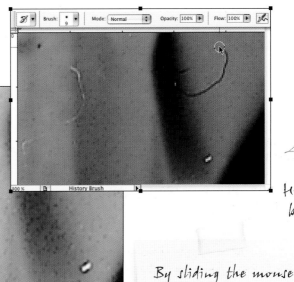

History brush

By sliding the mouse over each particle of dust it looked as if it was being sucked up. No, it was not a miracle ... it was Photoshop!

The History Brush tool is perfect for solving dust problems. However, since the Dust & Scratches filter tends to blur the image, things are likely to get even worse if an area that requires correction is too large. Therefore, I resort to the latest Photoshop tools: the Healing Brush tool and the Patch tool. ■

Stage 7

The finishing touch

In order to make the corrections, I used the latest Healing Brush and Patch tools. These tools very much resemble the Rubber Stamp tool from older Photoshop versions that beginners or old-timers still use (old habits die hard!). Just as each dab removed the sample that had been picked, these new tools also require a reference area in order to apply the texture, luminosity, and shade of the source pixels. The corrected pixels are integrated with the rest of the image and nothing shows.

Using two (screens on my work station

helped me control the image directly.

All I had to do now was to balance the entire image for perfect legibility. This 180° pan shot required luminosity compensation on some specific areas where the natural brightness of the sail provoked contrasts that were too strong for a photograph.

I resorted to some Curves adjustment layers (Layer → New Adjustment Layer → Curve) added to the copy of the image (shortcut Apple+G or Copy → Add to preceding copy) for which I delimited a selection thanks to the mask.

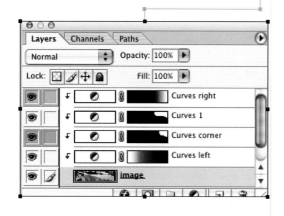

In order to freeze the values I did not want to modify, I clicked on a few corresponding areas in the image while keeping the Apple key in (dark points on the screen copy). Then, I kept clicking on the areas of the image that I wanted to modify. I evaluated the variation of the values (circle on the screen copy) and set their extremes. Finally I took the median point and gave the curve the direction I wanted it to take with the directional keys of the keyboard.

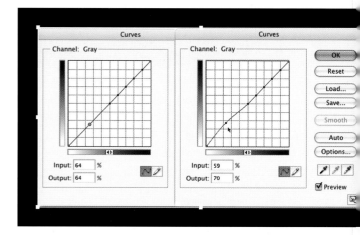

Some corrections were not flat: I had to give them some gradation. In this type of situation, the gradient transfer Curve command can prove useful, but it is much less precise. By playing with the gradation, its composition, its smoothness, and its transparency, I could see right away the luminosity corrections I was making.

So that I could view the gradation or any other layer masks, I simply clicked on the Mask control of the Layers palette. The ! key on the keyboard allows for a quick deactivation of the mask display. Thanks to the difference in colors and transparency of

Mask display

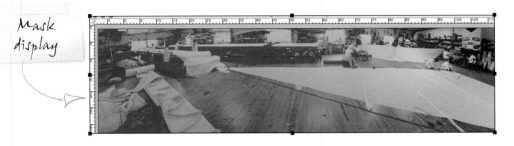

this alpha layer, this intervention enabled me to better visualize the progression of the gradation and the limits of the mask.

Editing

The image suited me and its size (14280 X 3835 pixels, or 103.4 MB) made it possible to consider various editing possibilities. The order that had been placed required a wide angle inkjet print and should measure 4 ft. X 14.6 ft. maximum.

In order to have a good quality poster, measuring 4 ft. wide and 1 ft. high, the file simply needed to be converted in CMYK according to the potential printer's expectations.

Before contacting the subcontractor for the final printing and delivery to the customer, I calibrated this image so that it could be printed (inkjet print) in an A3 format (approximately 6 MB).

Throughout this process, I sent JPEG files, to the photographer so that he had an idea of how his project was coming along.

Calibrating the screen

I never mentioned the calibration of the graphic chain. It was neither because of some loss of memory nor because of a lack of knowledge in that field. ICC profiles technology for color management is definitely the best approach. Each entry peripheral (digitizer, camera, etc.) or exit peripheral (screen, printer, etc.) has its own profile. In order to switch from one image mode to another (Lab Colors, RGB Colors, or CMYK Colors), parameters are also specified.

The most judicious and effective way to (**retouch** colors
*is to work on a screen that
has been properly calibrated.*

The most judicious and effective way to evaluate and retouch colors, is to work on a screen that has been properly calibrated in the RGB colorimetric space. This workshop was done in scales of gray starting from a black and white file. The color management parameters were deactivated since there were no colors to manage except, for a possible conversion. ■

API_ultim.psd @ 4% (image, Gris)

Width : 14280 pixels (120.9 cm)
Height : 3835 pixels (32.47 cm)
Curves : 1 (gray levels)
Resolution : 300 pixels/inch

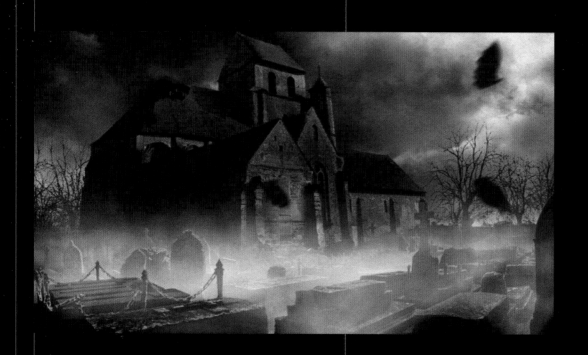

Before the development of digital technologies, matte painting was a technique that was reserved for glass artists only. Today, Photoshop, which skillfully combines both retouching and photomontage techniques, occupies an essential place in the field.

studio 06

THIBAUT **GRANIER**

Hardware used
- Nikon FE2 and Coolpix 995 cameras
- Nikon objective 35-70 mm
- Portra Kodak film 160 NC
- Nikon LS 2000 scanner
- Mac G4, 450 MHz biprocessor, 1 GB of RAM

Software used
- Photoshop CS
- After Effects 5.5

Bloody Mallory

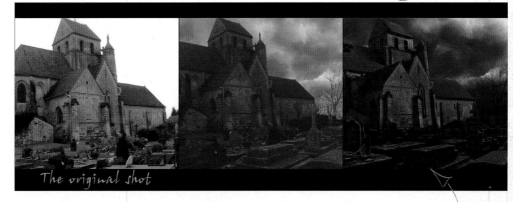

The original shot

Final image

Among the many special effects techniques that are used in the film industry, *matte painting* is the cheapest solution. It is also the most commonly used when it is necessary to put in a decor that does not exist

For Julien Tycoon's film *Bloody Mallory,* Mikros Image, a Parisian postproduction company, carried out special effects on over one hundred shots. I was entrusted with the creation of three matte paintings, one of which was to represent a night vision of an abandoned church, with a cemetery in the foreground.

The atmosphere had to be eerie and haunted . . .

Beyond the difficulty of integrating the elements in relation to one another, the (**credibility** *of an image lies in the creation of coherent light effects.*

Stage 1

The photograph

Thanks to the Internet picture library, we found the Church of Gouzangrez, in the Oise Valley. It caught our attention for two reasons. Its massive architecture met the producer's wishes and it had some badly damaged tombs—which corresponded perfectly with the "eerie" atmosphere that he was seeking.

The problem we faced was that the most interesting shot of the building covered the most recent part of the cemetery. It looked too "clean." It was thus necessary to photograph the tombs that were damaged separately, and then resort to a montage. Shots of the tombs were much more delicate to handle than those of the building. Indeed, right from the beginning, we had to keep in mind where each one would fit in the final montage. Their position and perspective were crucial. The fewer errors we would make during the shooting, the easier the montage would be.

The (**weather** matters a lot
in this kind of shooting.

If the majority of photographers express the subtlety of their talent thanks to the way they master lighting, it is much more difficult to assemble, in a realistic manner, images which do not have the same light directions. Since none of the tombs could be shot in the same ambient light, I resorted to a rather simple trick: the sky had to be overcast. Indeed, clouds serve as a huge light box which diffuses the sunshine and blends it. No shadows, no depths: it would be for us to recreate them whenever we needed them. ■

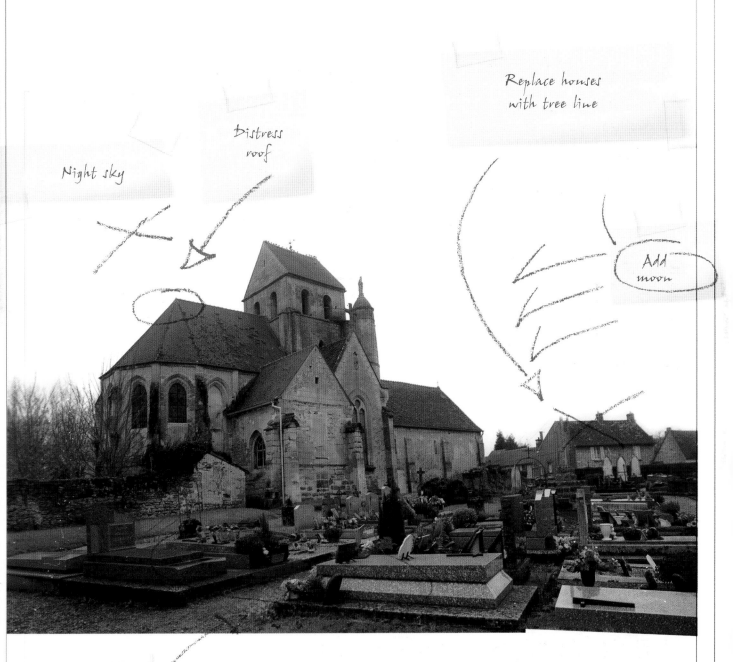

Stage 2

Creating the sky

Bloody Mallory was a fantastic action film inspired by low-budget films and mangas. As a consequence, some caricatures or inconsistencies were allowed, such as an extremely overcast and cloudy sky, which, nevertheless, was lit by a strong source of light.

The initial elements that were used to create the backdrop of the image consisted of two photographs of the sky that came from earlier shots. We placed the first photograph underneath a copy of the outlined church, in order to cover the entire horizon with clouds.

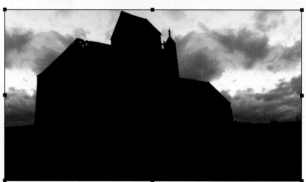

The second sky was interesting because of the clouds that were located in the top part of the frame. Once placed over the first sky, in Darken blend mode, it was possible to mix the clouds together and thus create a new sky, entirely covered with clouds.

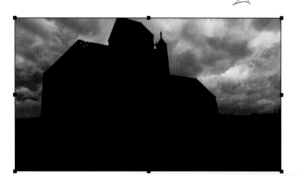

The Darken mode enabled us to mix both images without having to resort to outlining which, considering the subject, would have been very difficult to perform properly.

As for the two images of the sky, only the (clouds
were of any interest to us because of their low light.

composite saturation could be lowered and thus became more monochromatic. Then, a dominant color was added by shifting the shade variation and by selecting the "Colorize" option.

Since these two images were the result of two different shots, they had to be calibrated. A conventional calibration would have necessitated the modification of one sky in order to harmonize it with the other. However, in this case, both had equivalent contrast ratios—only their chromas differed. Thanks to a Hue/Saturation calibration layer, the global

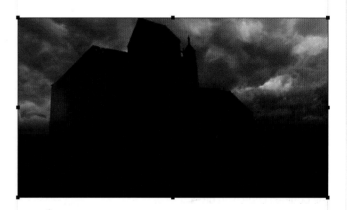

Thanks to a second calibration layer in Curves mode, it was possible to increase the composite contrast by overwhelming the lowlights. However, the sky should not be black. That is why we lifted up the foot of the curve in order to increase the value of the lowlights and make them more luminous.

We proceeded the same way for the moonlight. Then, we added some bits and pieces of very bright clouds to the sky, according to the Overlay blend mode.

Stage 3

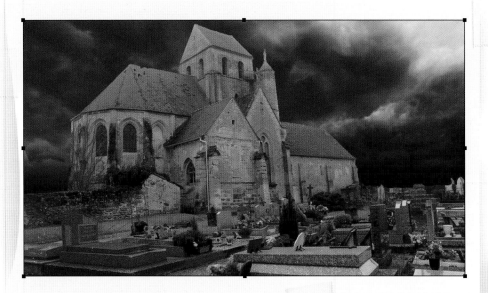

not a problem, since the image did not have too much of that to begin with.

We followed the same principle as when we calibrated the sky: a Hue/Saturation layer grouped with that of the church made it possible to lower the saturation of the church. However, we did not redefine its color, since it was important to keep the original colors relatively intact. That is why, this time, the dominant color was affected by a light opaque layer (50%) which contained some color taken from the sky. By the end of this stage, the church and sky definitely

"American night" calibration

American night (often called "day-for-night") consists of filming a daylight scene by under-exposing the image and by placing a blue filter in front of the lens. This is also widely used in digital special effects.

In order to under-expose the church, a calibration layer was created for each curve: a point was then selected in the middle of the layer and sharply lowered in order to make the image more dense. As a result, the slope of the curve increased in the highlights area and that gave them more contrast. That was

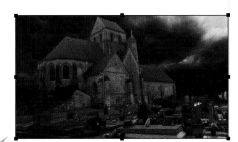

looked more homogeneous. Nevertheless, we kept all these adjustment layers as they were, so that they could be modified whenever the rendering would require it. ▪

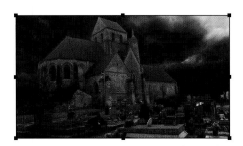

It was important to keep the original (colors
relatively present.

Stage 4

Making up the cemetery

The making up of the cemetery was a special phase. As we mentioned in Stage 1, numerous negatives were taken and they did not always have a similar exposure. Little by little, tomb after tomb, we selected the elements that we found interesting. We outlined them, calibrated them, and distorted them in the image foreground.

Photoshop's weakest point is layer distortion. The only major tool that could be used was the Transformation tool. Unfortunately, it offers very few possibilities when we compare it with the type of tools that come with After Effects, for example.

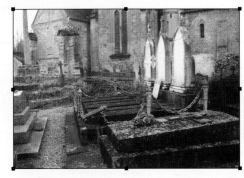

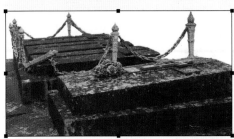

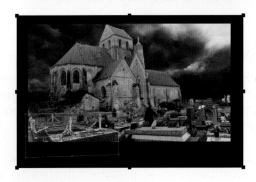

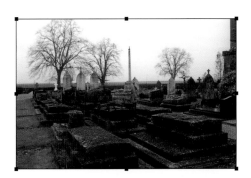

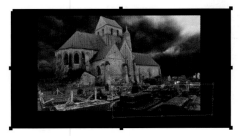

Throughout this process, we had to keep in mind that the image carried out with Photoshop was only the preparation of elements which were to be assembled and animated, using After Effects. Indeed, the sky was going to move and fog would be added between the tombs.

That is why each added element could never be dominated by the inferior layer of the church. ■

Stage 5

Shadows

When we were taking care of the sky, we suggested the presence of a strong source of light (the moon) located in the top right corner of the frame. Consequently, we had to create the shadows that derived from that light and which would constitute the densest parts of the image.

When we duplicated the copy of the church and put it under Multiply blend mode, its density sharply increased. The values that had been reached corresponded to the levels that we wanted to attribute to the shadows. By adding a black mask

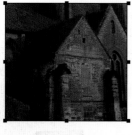

to the copied overlay, the latter disappeared entirely, revealing the original church underneath. It was in this mask that we were faced with the most delicate task: using white flats. Using either the lasso or the brush, we had to restore all the areas of the church that were not lit and that had been darkened by the various shadows that had been added to the shapes.

Here is a trick: we applied colored effects to the masks of the shadows we had just obtained. For example, the shadow effect made it possible to create various color gradations (blue on the illustration) all around the shapes we had just outlined. We matched the colors we had just applied to those of the source (white) and shadows (generally blue). Now, if we selected the proper blend mode, it would be possible within a few, simple actions to give the shapes richer, yet irregular lighting effects without having to retouch the whole thing, step by step. The last image shows the result that we obtained. ∎

The shadow mask

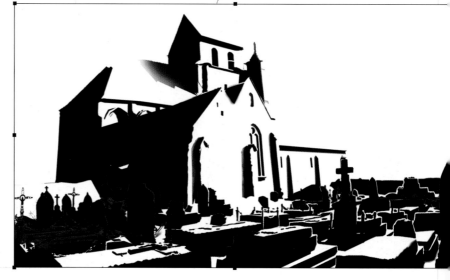

Once the same operation had been carried out on each layer of the tombs, we could start thinking about the final rendering of the decor.

Stage 6

Final touch

It was essential to polish up the rendering and improve the integration of the various elements in order to obtain a perfect montage. For example, even if the linking up of these elements had been correctly calibrated, overly sharp outlines would show. Therefore, each mask had to be carefully checked and cleaned of any imperfections. Potential blurry effects, due to relative distances and depth of field, also had to be taken into account.

Let us not forget that other people were going to take over. This image had to undergo new modifications and it was not meant to be viewed on a computer screen, but in movie theaters.

In order for the special effects person to integrate the animation effects he was going to add using After Effects, it was basic to make our project as simple as possible. So we fused as many layers as we could and still ended up with more than 15! The special effects person could probably use the shadow masks: we saved them all in the stack of image layers.

Even when we believe that the (decor **finally represents**

an homogeneous universe,
the job is not quite done yet.

All we had to do now was to check that the images matched the output calibration profiles that are specific to the cinema. In the case of our church, which represented an extremely dark universe, the wrong set up could have disastrous consequences when viewing time came: the risk was that nobody would see anything . . . ■

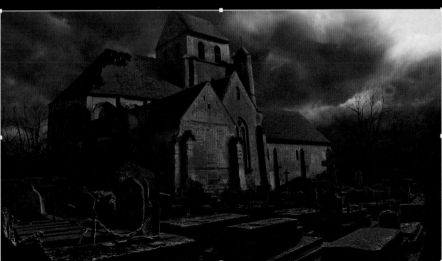

Of course, the peculiarity of retouching is that it should not be seen as such. In other words, nobody should realize that an image has been touched up. Put another way, for a retouching to be successful, it should look natural. The image I picked went against all the points I have just mentioned since it dealt with the creation of a surreal universe with all the artefacts that such a project entailed. However, my objective was to make that image as "realistic" as possible, although, in this context, the term realism was highly subjective. This is what I had in mind: if I could ever take a photograph of my character wandering through the Milky Way and starry universe, in a convertible van, the result would look somewhat like this image . . .

POISSON **ROUGE**

Hardware used
- Nikon Coolpix 950
- Mac G4
- Electronic paint system

Firefly

Software used
- Photoshop CS

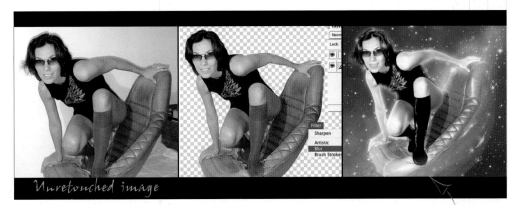

Unretouched image

Final image

Most of the time, retouching is used to perfect a photograph that is already structured (composition and lighting). The retoucher's goal is to render the effects of his work as discreetly as possible. The choice I made here was to use all the potential that retouching provides and apply it in the same way an illustrator would. I was to create a surreal universe based on a "realistic" shot.

Yet, the realization of this image made it possible to tackle almost all the aspects of traditional retouching: outlining, skin cleaning, and—more generally—as well as lighting and colorimetry.

I was to create a surreal (universe

based on a "realistic" shot.

Stage 1

Preparing the ground

This essential phase may seem tedious and unsatisfactory. It consists of using various handy tools that allow one to outline different types of shapes and surfaces (hair, skin, armchair).

This methodical work proved to be very beneficial for the final picture.

Experience has taught me that the better the preparation, the better the final result. That initial preparation enabled me to better concentrate on each following phase (cleaning, formatting, lighting effects, etc.). The work ended up being a lot more constructive.

The second outlining phase was carried out in Quick Mask mode with the Airbrush tool. It completed the work I had just done since it enabled me to focus on softer, or blurred contours.

Experience has taught me that the better the (preparation, *the better the final result.*

I started by outlining both the character and accessories completely. The Pen tool allows for a very precise outlining of contours. However, it does not work as well with shapes which are not clearly defined or which are very fine (hair or blurs). What I did was to outline them roughly.

The third outlining phase required the Smudge tool, which allowed me to stretch the surface of the mask so that it would perfectly mould the irregularities of the forms I needed to outline. Therefore, I had to push the mask between the areas that were "frayed," such as her hair, as much as I could. ∎

Meticulous outlining helps avoid unpleasant surprises later on (porous copies, jagged contours, etc.).

Once that was done, I masked the background. I applied a Gaussian blur in order to soften the contour a little while respecting the sharpness of the shot.

Stage 2

Cleaning

It was during this phase that the first spectacular effects of retouching would start to show. However, before going any further, I still had to spend some time "dusting" the image. No matter what kind of original support you work on (scanner based on an ekta or a negative, or digital shots), there is always some dust that needs to be cleaned by using the Clone Stamp tool. That's the final "chore."

I could now move on to more serious matters...

Smoothing should remain (moderate **for**
a natural touch.

Smoothing makes it possible to attenuate the grain and skin imperfections as well as the irregularities of certain surfaces. Skin smoothing can be more or less intensive according to the type of rendering the artist wishes to achieve: moderate for a natural touch and extreme for "glamor" type renderings, as is often the case in photo advertising for cosmetic products.

As for my character, I chose an intermediary approach, since the lunar lighting effects that were to come would emphasize the smoothed and slightly artificial aspect of her skin. I used the Clone Stamp tool to smooth her skin and worked on the opacity according to the effects I wanted. ■

The difficulty of this exercise consisted of preserving the light of the original shot and in respecting the shadows and light, so as not to overwhelm or modify the character's shapes (her face, feet, hands, and knees).

Stage 3

Updating

Next I had to simplify the forms and give the whole thing a more elegant feel. That gave me the opportunity to renovate and repair a 30-year-old chair that definitely showed signs of wear and tear.

With the Clone Stamp tool, I duplicated the "healthy" parts of the chair in order to patch up the parts that were damaged.

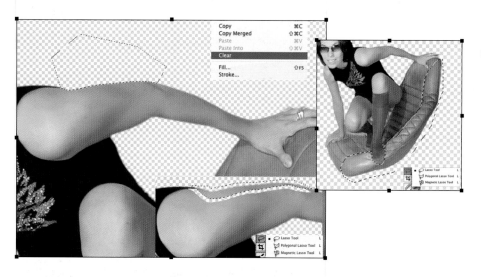

First of all, I selected the part of the seat that I wanted to distort.

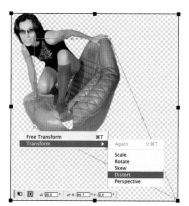

I took advantage of this stage to get rid of the folds in the tee-shirt, which could make the model look bigger than she was. I also reduced the apparent thickness of her arm that the angle of the shot had created. In order to do that, I simply "cut out" the undesirable parts.

It was also during this phase that I gave the chair the shape I had planned to give it when I designed the image, before I shot it.

Then, I gave it the chosen shape by applying a distortion.

The graft and distortion phase was almost over now. However, I still had to add some grain where the distortion had produced a fuzzier image. ■

Stage 4

Creating the starry sky

It is often easier to create your own starry sky and Milky Way than to photograph them.

I created an additional layer and filled it with a bluish, black flat. That would be my night.

On that same layer, with the airbrush, I started to paint the edges of the Milky Way in a lighter blue. I picked a wide, slightly opaque brush to do that.

Then, I switched to a bluish white shade and a slightly narrower brush to give a fuzzier aspect to the heart of the Milky Way. I applied the color in successive dabs.

Next came the stars . . .

In order to simulate the depth of the universe, I decided to create stars which would be different in size and sharpness.

I added one layer for the most remote stars, which would be the fuzziest. With a small brush, I painted small, sharp dots before giving them a Gaussian blur.

On a second layer, the stars in the foreground would be the sharpest.

On the third layer, I gave each star a bright halo by using a low opacity brush in order to diffuse contours.

Finally, so that some stars would twinkle more than others, I decorated them with a particular sparkle, a sort of vague asterisk, to make them scintillate. ■

The composition of the backdrop was determined by the subject. By placing the Milky Way diagonally in relation to the image, it gave the impression that the character was moving.

Final image

Stage 5

Colorimetry

When retouching entails major modifications (smoothing of the skin, mending, formatting the elements, etc.) colorimetry is essential. It gives the image its personality.

Much more than with mere color changes, colorimetry helped me reproduce the lunar and fairy-like atmosphere. Several adjustments were necessary to reach that objective.

When I work on this type of color retouching, I always bear in mind the kind of final support the image will have (printing or Web page). Here, the paper print implied that, right from the start, I had to operate in CMYK mode.

The image could not be converted at the end of the retouching process, because switching from one mode to another (RGB and CMYK) could lead to the loss of certain information.

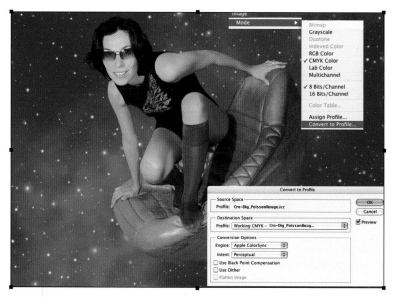

I used adjustment layers which gave me great freedom of action. I was able to go back to each phase without having to worry about the different stages of the history.

The last corrections enabled me to make specific modifications on each element, without spoiling any of the effects I had already given them.

Consequently, I accumulated color corrections without having to resort to outlining again. Eventually, that could produce undesirable edgings on the image.

Colorimetry rebalances colors of the same visual. It contributes to the binding of elements between them. It is what makes it possible to create a specific atmosphere for each image. Here, it allowed the highlighting of the artificial aspect of the image. It emphasized its "lunar" and "fairy-like" touch.

I selected each element and attributed it its own colorimetry curve (using the Curves tool). The difficulty lay in the fact that I had to respect the way each texture and each surface would absorb or reflect an "astral light." I thus picked a velvety rendering for the skin and a shiny one for the leather of the armchair.

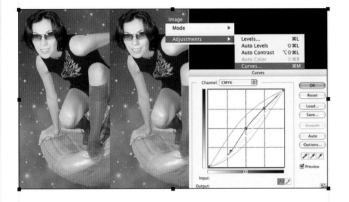

It was necessary to preserve the freshness of the skin while bathing it in a bluish light. I decided to give more blue to the shadows and to preserve the velvety and slightly rosy aspect of the lighter parts.

The colorimetry carried out on the armchair completed the preceding phase. I had to avoid giving the skin too much of a bluish shade or it would look morbid. To compensate for this I enhanced the

blue on the armchair. To finish, I accentuated the shine of the leather in order to underline the glitter of the stars and evoke the reflections they should cause on the leather.

I also wanted to transform her stockings into "space boots". I thus gave more density to that part of the image until the texture of the mesh completely disappeared and took on a uniform and smooth aspect. I enlarged the folds around the ankle to give the illusion of a thicker material.

Orange-red was chosen for her hair to balance the whole image. This warm color gave a softer look to the character. By the same token, it gave the image a central focal point. Indeed,

that orange-red, a complementary color of midnight blue, highlighted the whole picture thanks to a colorimetric contrast. The goal here was to focus the attention on the character. ■

Stage 6

Harmonizing the whole

The last stage in the completion of the image was its harmonization. The time had come to polish it up. Usually, it is a matter of retouching a few details here and there that reinforce and complement one another. Here, everything was done thanks to the Airbrush tool.

Right from the beginning, my objective has been to make the character omnipresent. Everything must seem to derive from her.

I started by wrapping the character in a luminous halo. This is what helped produce that luminescent aspect, as if the light emanated from her as much as from the stars. It was also a means of exploiting the depth of the image by putting the character in the forefront, when compared to the armchair.

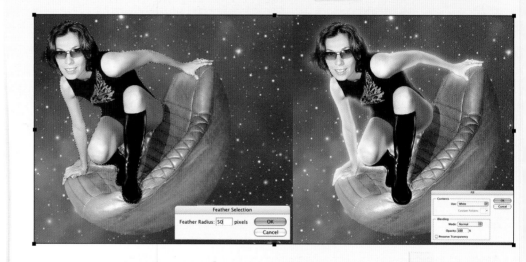

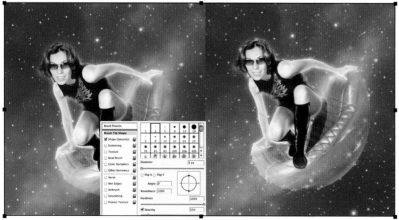

It was also necessary to reinforce the reflections. To do so, I picked a low opacity brush and applied specific halation here and there to give the illusion that the light emanated from the image.

I added a sparkling effect in order to blend the character into the decor even more and stress the fairy-like evocation. To do so, I used a very small, hard brush and painted spangles.

I thickened the nebula in the center of the image, in order to give even more intensity to the brightness of the character.

Stage 6

Finally, I made the sky and stars slightly fuzzier. As a consequence, the character looked sharper.

It is always a good idea to take a break and get away from the image for a while and allow the eye to rest. Every project is always perfectible, but it is also necessary to know when to stop.

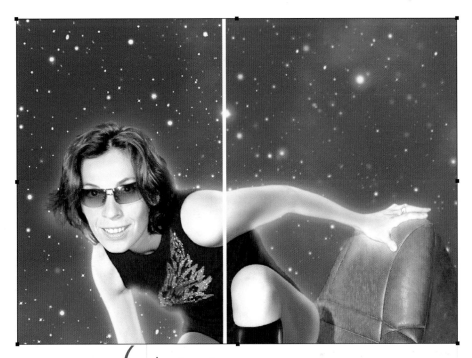

I applied one last (colorimetry curve (using the Curves tool)
to reinforce the colors once again.

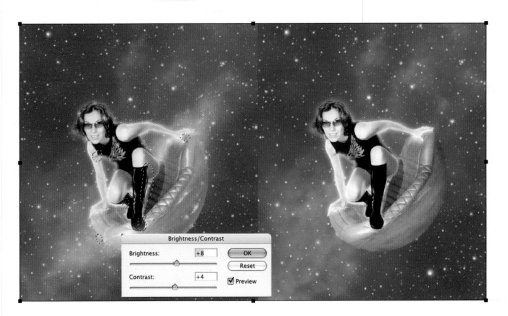

After taking a short break, I came back to the screen. I got rid of a few bugs in the reflections. I applied one last colorimetry curve (using the Curves tool) in order to reinforce the colors once again and I regulated the shadows and light values. ■

Photo retouching in the context of a packaging for a publicity campaign consists of giving an immediate and clear vision of the products that are presented by removing everything that could divert people's attention. However, they are shown the facts. When they look at this image, then at the real products, they do not feel as if they were misled.

studio 08

Hardware used
- Sinar P 4×5 view camera
- Provia *Fuji film
- Lighting sources: lighting box
- G4 dual-processor 533 MHz
- 1.5 GB of RAM
- Gretagmacbeth Eye-one spectrophotometer

Software used
- Photoshop CS

Aroma

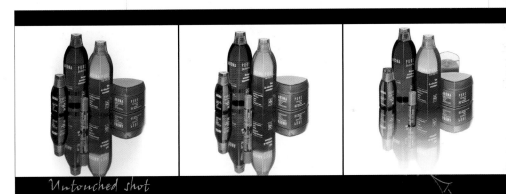

Untouched shot

In order to illustrate this studio, I chose an image of beauty products which clearly showed the different problems one regularly confronts when retouching studio shots. These were some of Yves Rocher's Aroma cosmetic line. The advertising agency, Lowe Alice, is very demanding when it comes to the quality of the images. It demands esthetics and meticulousness. The products that are photographed must be readable and identifiable straight away. In order to meet that objective, the agency called on one of the most famous still life photographers, Christian Cournut.

My work then consisted of making this image more readable by removing the typography on the back of the products, which were transparent, and in harmonizing the reflections on the bottles.

Final image

It is necessary to work on the (legibility of the image without *betraying the products themselves.*

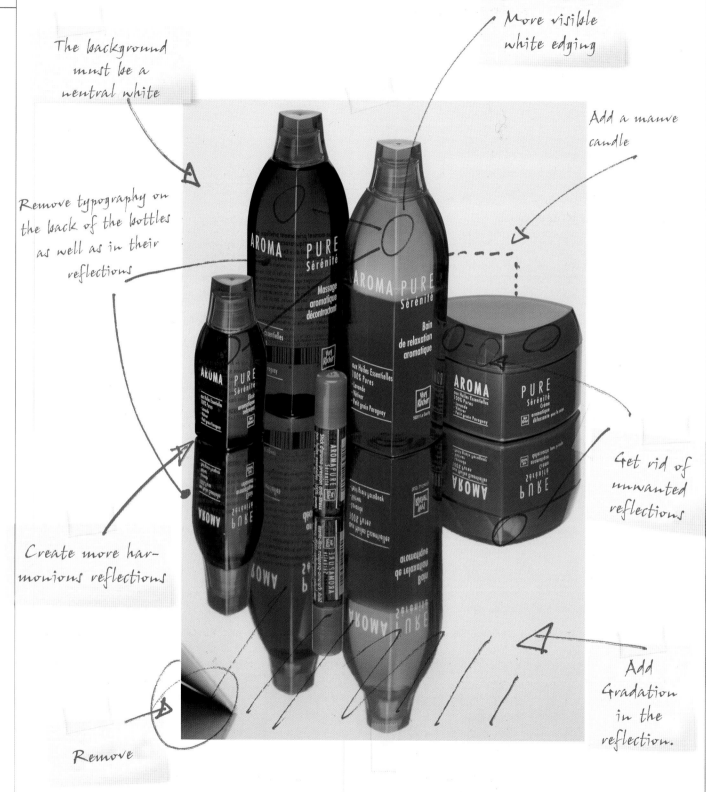

More visible white edging

Add a mauve candle

The background must be a neutral white

Remove typography on the back of the bottles as well as in their reflections

Get rid of unwanted reflections

Create more harmonious reflections

Add Gradation in the reflection.

Remove

Stage

The shot

If the finality of the work presented here was the retouching of the image, it was essential to take a closer look at the shot itself. In this kind of retouching it is very important to know what you are looking for, right from the beginning: the fewer manipulations on the original photograph, the better the quality of the final image.

Light box

Mirror

Reflector

Light box

View camera

The products were set on a very clean mirror in order to have beautiful reflections. They were lit thanks to two sources of light, called light boxes. These are boxes that are closed by a Plexiglass plate, inside of which several large flashes are placed. They provide a diffuse and homogeneous light.

The largest box was placed behind the products so as to give a nice, white support and transparency to the bottles.

A second box was placed in front of the products, to light them. However, the latter was slightly off to the side to add contrast.

Then, by using several white card boards of various sizes, the light was reflected on areas that were a little too dark, or to create slight gradations. On the other hand, black card boards would stop the light. This technique enabled us to direct the light in a very precise way and create beautiful reflections in the liquids. ■

The etymology of ("to photograph" **means:**
to write with light . . .

Stage 2

Preparing the ground

It is always best to set a work scheme right from the beginning. It is very important to think about the way you wants to reach your goal in order to avoid doing things unnecessarily. Very often, when the retouching work is finished, the customer, or the agency, require modifications—and that is why it is necessary to plan the different steps of the project.

Here, for example, I indicated that I wanted a white gradation in the reflection. My choice might not correspond to that of the agency: it might prefer a lighter, or denser gradation. That is why I put that reflection on an individual copy so as to regulate its intensity later on.

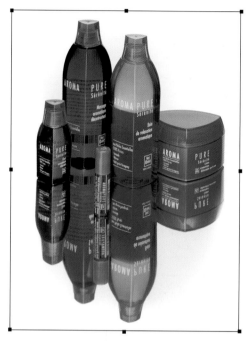

The RGB file is lighter than the CMYK file, therefore it is easier to use.

I decided to work in RGB and to convert everything to CMYK at the end of the work. That way, if the photoengraver decided to do the conversion herself, in order to adapt it to her printing machines, I would be able to give her an RGB file without having to start all over again.

The screen needs to be re-calibrated quite often, because its values change with time. As far as I am concerned, I do that each week.

First of all, I calibrated my screen to make sure my colors were all right. I used the Gretagmacbeth Eye-one to do that. It is very important to work on a properly calibrated screen, since you use it in order to adjust colors. Of course, the products in the photograph must without fail have the same colors as the real ones.

This is how I was going to proceed: outline all the products and their reflections, remove the typography on the back of the products as well as the unwanted reflections and, finally, work on the white gradation. ∎

Stage 3

Outlining

It is imperative to master outlining well in order to do a good retouching job. It must be precise and it often takes time. There are several ways of outlining an image. For the bottles and their reflections, I picked the Pen tool in order to carry out a precise selection. This tool works very well with geometrical forms.

The Pen tool is delicate to handle at first, because it is difficult to learn how to use the directing points and anchoring points properly.

However, it is worth some perseverance. It is one of the most precise tools available and often provides very good results.

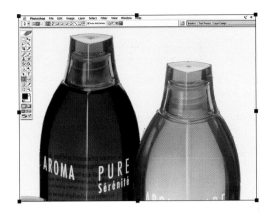

Precise outlining with the Pen

Once I finished, all I had to do was transform it into a selection. In the options at the bottom of the paths palette, I chose Create a Selection from Path. I picked a 1-pixel radius in order to have a rather clear-cut selection. ▪

Rough outlining with the Magic Wand tool

The Magic Wand tool, for the type of outlining we are dealing with here, gives a "staircase-like" selection. It lacks precision and does not provide quality results.

Stage 4

It is important to name your layers properly, because their number increases very quickly and it is essential to see where you are going. You can even form groups of layers when there are too many of them.

Creating a layer mask

Now I had a selection based on the products. I transformed the background layer into a normal layer by clicking on it twice. It is not possible to apply a mask on the background layer. I named it "Products." I clicked on the "Add a Mask" icon, at the bottom of the layers palette. The outlined products appeared.

Next, I created a new layer which I filled with white. I named it "Background" and I placed it underneath the Products layer so as to give the image a brighter appear-

ance than with a checked background. This also made it easier to see potential flaws in the outlining.

I prefer to use a mask rather than eliminate a part of the background which does not interest me. The mask also enables you to come back to a selection if need be.

When in Mask mode, it is possible to refine outlines by painting the areas you wish to hide in black and the parts you wish to reveal in white. This could not be done if the background had been erased. ▪

In this example, it was not necessary to come back to the outlines that often, because the forms were rather simple to outline with the pen. This is relatively rare. In the majority of cases, I use the Brush tool to work on the mask and do spend a lot of time on it. For example, when I deal with transparencies, gradations, blurs, or complicated forms . . .

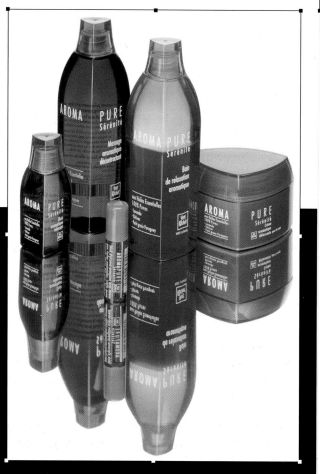

Stage 5

Protecting typography from the rear

Seeing the quantity of the characters that needed to be erased on the back of the first two bottles, I decided to re-do the liquid inside, rather than remove each letter one by one.

In a new layer that I named "Inside bottles," I would recreate the color of the bottle. First, I had to allot a mask to that layer in order to protect the areas I did not want to touch. All that would be in black in the mask would be preserved.

It does save time when you know the short-cuts on the keyboard! It prevents you from displacing the mouse in the tablets and the menus. It also allows you to gain more room on the screen because some palettes can be closed.

With the lasso, I made a rough selection around the letters, then I took a sample of their color with the eyedropper tool. In the Select ➤ Color Range menu, I saved a selection of the letters that I wanted to keep. By moving the tolerance, I stopped on the value which not only gave me white letters, but really black bottles so that in the end, the computer would select the letters alone. I quickly got a very nice selection.

In the Layer menu, I selected Add Layer Mask for the selection. I proceeded the same way for each letter and each vertical edging. This would enable me to paint my reflections while preserving the typography.

Protecting the background

The background also had to be protected in order to paint only on the products. To do that, I recalled the selection of my products again by clicking on the Products layer mask, while pressing the Command key. The product selection appeared on the screen. Then I inverted it (Cmd+Shift+I) in order to keep the background selection only. Once the Letters layer mask was activated, I selected black as my background color by pressing the D key. I filled the selection with that color while pressing Alt+Return. ■

Stage 6

Recreating the inside of the products

With the Pen tool, I made a selection of the mauve area I had to work on.

I started by painting in mauve with the brush, very roughly, in order

to get rid of the letters on the back of the bottles. With the eyedropper, I made sure to select exactly the same mauve color.

Then I took a fairly large brush (30% opacity, with a 50% flow), and played with the various mauves to recreate a liquid with all the nuances and gradations it might have.

I did the same with the reflections. With the bottle on the left it was even necessary to create new reflections to make it more "attractive" and give it more presence. The photographer had shown me a version of the photograph taken under a different light. It would work better for this bottle: the reflections were more harmonious and the large black flat has disappeared.

Retouching comes in whenever something cannot be done through a direct shot. Here, the photographer took a picture in which the light was perfect for four bottles out of five. When he regulated it to take the last bottle, the other four did not look as nice. The re-toucher is able to obtain an image in which the light on each product is exactly where the photographer wants it to be.

I thus outlined this new bottle and applied it on a new layer in my image. I used the Displacement tool so that I could place it precisely over the other layers.

Then I reduced its opacity to 50% in order to see the product that was under-neath and to position it exactly where it should be. With the Transforma-tion portion of the Move tool, I gave it a slight ro-tation (the scans were not positioned strictly in that same way).

You can use the arrows on the keyboard to move the layer with extreme precision before validating the transformation.

Stage 6

As in Stage 5, I protected the letters on the back of the bottle and selected each color.

It is very difficult to preserve both the material the bottles are made of as well as the appearance of the liquid. Usually, whether you are touching up a face, a product, a sky, or anything else, the problem you encounter is preserving the material. Photoshop is a very powerful tool but it is not "magic," unfortunately. It requires know-how and patience.

Here is the result I got after a little work.

Before

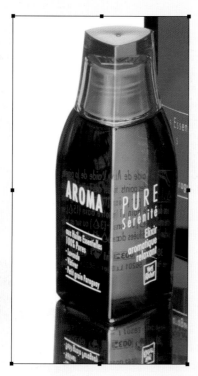

After

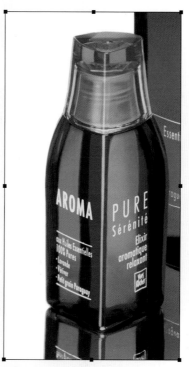

This step was particularly important because I need to recreate the inside of the first two products. The reflections had to look real. They had to correspond to the atmosphere the photographer wanted to instill through the type of light he had chosen. Of course, the same modifications had to be made in the reflections of each product. ▤

S t a g e 7

Inserting the candle

Once I had outlined the candle on another photograph, I applied it on a new layer that I named Candle. I placed it beneath the Products layer in order to put it behind the cream jar.

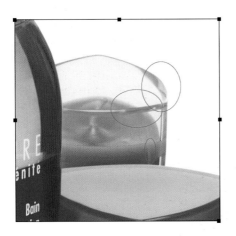

Looking at the candle, I noticed some unsightly reflections.

I would touch them up on a new layer called Candle reflections (it was better to do this on another layer to be able to return to it, in case I made a mistake).

I started by calling in the selection of the candle (Command+click on the candle layer) to touch it up and was careful not to go over the edge of the background.

With the Clone Stamp tool, I removed the unwanted reflections and created a more harmonious glass rim.

It is important to make sure that the (Use all layers *option is activated.*

To give the candle wick a fresher look, I used the lasso and selected it. I chose a 5-pixel tolerance so as to have a rather progressive selection. Once I got the right selection, I chose a Luminosity/Contrast adjustment layer: I added quite a lot of luminosity but little contrast. ∎

Adjustment layers are very handy because they make it possible to return as often as required to the values of each layer.

S t a g e 8

Unsightly reflections

On this image, one can distinguish two kinds of problems: small "sparkles" and more significant reflections.

I usually use the Clone Stamp at 100% to remove dust and small "sparkles," then come back to what I have done with the same tool but, this time, I used it at 30%, in order to remove what could still be seen.

I do not think that there are specific rules that apply to the use of the clone stamp, since each image has its own characteristics. First, the surface that needs retouching should be closely observed so that whatever has to be done remains as discreet as possible. The size of the tool, its opacity, and its color mode have to be carefully selected.

To correct the most visible reflections—where the cream jar reflected in the bottle—I selected the part that I had to work on with the Pen (Line) tool. What interested me here, was the border between the two color areas, because I wanted to create a reflection with a progressive gradation. When one looks at the mauve color in the center and at the darker mauve color on the right part of the bottle, the transition between the two is progressive. It was extremely important to preserve that transition so that the retouching phase would look as realistic as possible.

Once the lining phase was over, I chose Load Path as a Selection at the bottom of the paths palette. Within that selection, and on a new Reflections bottle 4 layer, I removed any unsightly reflections that were left from the clone stamp and the brush. I masked the selection (Cmd+H) to see what I was doing.

With the polygonal lasso, I selected the retouching parts that had been gone over by moving along the right side of the bottle. I erased them with the Return key. ∎

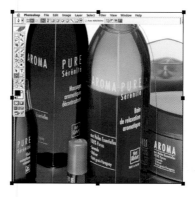

Stage 9

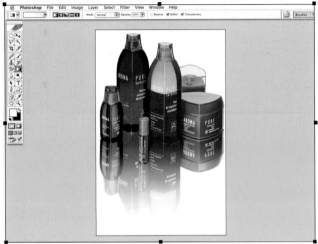

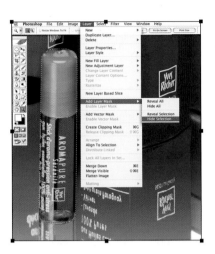

The white gradation

I was going to create a gradation which would let the reflections of the products show progressively. I placed a new layer named "Gradation" over the Products layer and then picked white as the foreground color. With the Gradient tool, I selected a linear gradation between the color of the foreground and the transparency. Finally, I started at the bottom of the image and stopped at the base of the large bottles.

You can see that the gradation went over the small bottle in the foreground. It was thus necessary to create a layer mask in order to hide that part of the gradation. The first thing I did was to select the small bottle with the Pen tool, which was ideal for a geometrical form like this.

I transformed the line into a 1-pixel selection (so that it would be sharp).

In the Layer → Add Layer Mask → Hide Selection menu, I again changed it to a mask. That gave the impression that the gradation had gone behind the bottle. ∎

Stage 10

Final touches and verifications

I went through the entire image once again to check if there were any flaws that I had to eliminate (such as dust, an outline that was not quite perfect, or a layer that had moved). This was an essential phase since I did not want to send a file with errors in it to the printer.

Therefore, I looked at each part of the image according to the real size of the pixels by clicking on the magnifying glass (or by using the Cmd+Alt+0 short cut on the keyboard).

I started at the top left-hand corner of the image, and very meticulously scanned it with the Beginning and End arrows. These allow you to screen an entire image and not miss a single thing.

I believe that this technique is much more rigorous than using the Hand tool.

In a new layer named ("Final touches," **I got rid of** *all the small flaws . . .*

Once that was done, I saved my image with all its layers on my hard disk. I saved a flattened version of it (in TIFF format, without compression) once I had removed all the lines. That one was for the photoengraver. The retouching was now entirely done . . . ■

In a new layer named "Final touches," I got rid of all the small flaws by using the clone stamp. Of course, I placed that layer over all the others.

I then printed the image in on A4 paper from my photo printer. This enabled me to spot details I might not have seen otherwise.

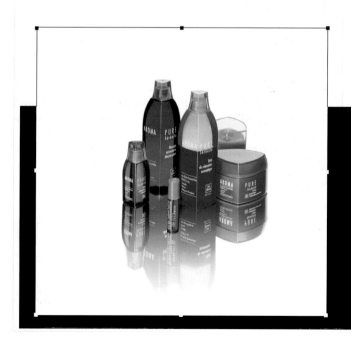

the authors

CYRIL **BRUNEAU**

Photographer, retoucher

Cyril Bruneau is a photographer in the advertising and illustration fields. He discovered the digital tool ten years ago and saw it as a fantastic means for creating his images. Today, people contact him regularly not only because he is an excellent photographer, but also as a master of the art of retouching and creating photomontages.

He has worked for some of the world's most famous companies (including Disney, Yves Rocher, Cartier, Société Générale, Air France, and Vinci) as well as for various magazines and newspapers (including *Paris Match* and *Le Monde*).
www.cyrilbruneau.com

THIBAUT **GRANIER**

Retoucher, photomontage and special effects technician

As a freelancer, Thibaut Granier works primarily for audiovisual postproduction and various news organizations.
tibog@free.fr

DOMINIQUE **LEGRAND**

Trainer/expert in digital imagery (Trait d'union graphique Company)

With a degree from the Estienne School, Dominique Legrand is a specialist in photoengraving. He trains people to use Adobe Photoshop and color management. He is the author and editor of a reference guide, *Printed Color: Directions for Use*, as well as several CD-ROMs on self-training, including *Photoshop know-how*. He is also the president of the Photoshop Club in Paris.

ANTONY **LEGRAND**

Image creator

Antony Legrand has a communications and graphics background. He participated in the design and writing of Studio 2.
www.clubphotoshop.org

ÉRIC **MAHÉ**

Image creator

Eric Mahé has been a photographer and data processing specialist for more than twenty years. A Photoshop buff, he has not stopped exploring the digital universe since discovering the potential that digital tools provided him to retouch his own images.
emmahe@club-internet.fr • www.ericmahe.com

GÉRARD **NIEMETZKY**

Adviser and trainer in color management and digital printing

Gérard Niemetsky graduated from Louis Lumière in 1978. He worked in different laboratories before creating his own group of professional laboratories which he ran until 1996. In 1980, he got involved with the development of micro-processing, and in 1990 in the development of digital images. When he was in the U.S. between 1998 and 2002, he devoted his time to the development of a color photographic process by mixing a 19th century coal process with the latest techniques in digital imaging. Back in France in 2002, he wrote the first French book on color management, published by Eyrolles Editions.
gerard@gestiondescouleurs.com • www.gestiondescouleurs.com

FRANÇOIS **QUINIO**

Author of images

François Quinio has been fascinated by photography for 45 years. He teaches professional photography and is always on the lookout for new developments in his field. His attraction to novelty pushed him to meet the photographers and suppliers who have been long-time believers in digital technologies. He became an adviser and participated in the development of the first studios equipped with digital sensors. Today, he leads a more secluded life but keeps on making images and sharing his insights.
francois.quinio@wanadoo.fr

POISSON **ROUGE**

Digital retouching studio

Poisson Rouge, a studio specializing in digital retouching, photomontages, graphic creation, and visual communications, was founded in 1997. In 1999, they added a 3D-creating cell. Most of the images made by Poisson Rouge are produced in collaboration with photographers and/or advertising agencies. Poisson Rouge works alongside photographers right from the design phase, and maintains a close relationship with the engraving specialists to ensure optimal quality in the printed images.

www.poisson-rouge.fr • poisson.rouge@wanadoo.fr

VINCENT **RISACHER**

Photograver-scanner specialist

Vincent Risacher trained as a photoengraver and scanner specialist. In 1992, he started his own business in digital image processing. He has his own workshop and teaches in various training centers. He is the author of several books on Photoshop (published by Eyrolles Editions). Adobe qualified him as a Photoshop expert and since then, he has started a collection of graphics resources named "Goodies" which are accessible on his website.

www.photogoodies.com.

THE TRANSLATOR

MARIE-LAURE **CLEC'H**

Translator

Marie-Laure CLEC'H started her own translation company in 1984 in Washington, D.C. Her clients included the U.S. Department of Commerce and the Agency for International Development. In this capacity, she also taught French to U.S. State Department officials. She is now established in her native Brittany (Western France), where she has created a new company called English Translation Services.

studios

GÉRARD **NIEMETZKY** *Image Restoring*

DOMINIQUE **LEGRAND** *Digital Surgery*
ANTONY **LEGRAND**

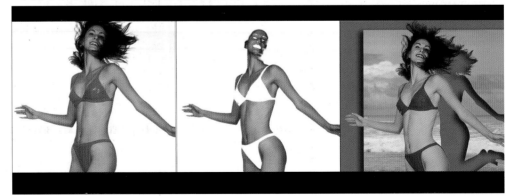

ÉRIC **MAHÉ** *Late afternoon in Nosy Be*

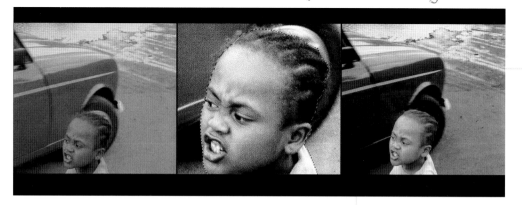

VINCENT **RISACHER** *Beauty Institut*

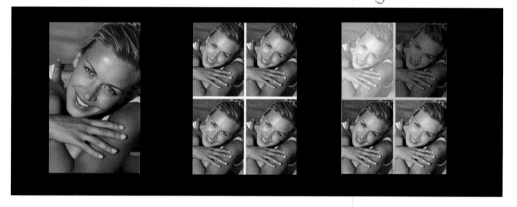

FRANÇOIS **QUINIO** *Sails, Perspectives, and Curves*

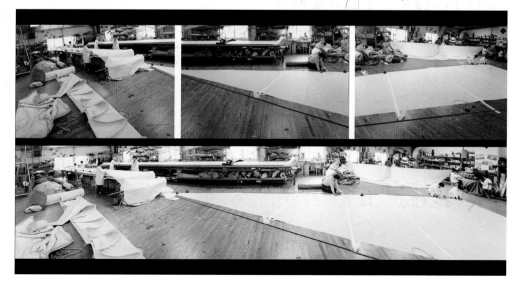

THIBAUT **GRANIER**

Bloody Mallory

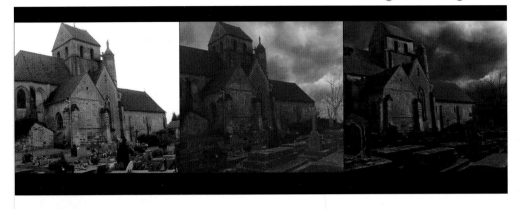

POISSON **ROUGE**

Firefly

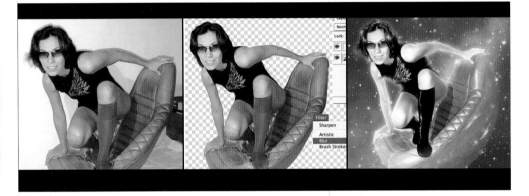

CYRIL **BRUNEAU**

Aroma